IMAGES
of America
GALESBURG

ON THE COVER: **BROTHERHOOD DINNER.** The Brotherhood of Locomotive Firemen and Enginemen entertains the Grand Lodge of the Ladies Society. On December 22, 1911, the brotherhood gave a dinner for the Ladies Lodge of their organization. (Courtesy of the Galesburg Public Library.)

IMAGES
of America

GALESBURG

Patty Mosher

Copyright © 2015 by Patty Mosher
ISBN 978-1-4671-1478-3

Published by Arcadia Publishing
Charleston, South Carolina

Printed in the United States of America

Library of Congress Control Number: 2015950117

For all general information, please contact Arcadia Publishing:
Telephone 843-853-2070
Fax 843-853-0044
E-mail sales@arcadiapublishing.com
For customer service and orders:
Toll-Free 1-888-313-2665

Visit us on the Internet at www.arcadiapublishing.com

To Tom Wilson, who has been a friend and mentor and who gave me the encouragement to write this book. Also to Nancy Terpening, who went to bat for me to obtain my dream job, and to Pam Van Kirk, who made it a reality.

CONTENTS

Acknowledgments		6
Introduction		7
1.	Galesburg: The All-American City	9
2.	Businesses: The Door to Opportunity	21
3.	Churches: The Lost and Found Department	47
4.	Government and Services: The City at Work	55
5.	Colleges: The Key to the Golden Door	61
6.	Industry: A Better Mousetrap	69
7.	Railroads: Links to Vast Spaces	77
8.	Schools: An Investment in Knowledge	93
9.	Recreation and Culture: Why We Love the Burg	101

Acknowledgments

I would like to thank the following individuals for providing photographs to add to the book. In alphabetical order, they are the following: Robert Ahlenius, Eric Berg, Sharlene Brooks, Penny Brown, Peter and Sherry Brown, Harry Bulkeley, Steve Crane, Doug Donovan, Pat Fox, Bill Frankey, Ted Grothe, Martha Hallstrom, Mrs. Dale Humphrey, Pat Indelicato, William Jewsbury, Helen Kilby, Jerry and Linda Lacy, John Lotspeich, Jesse Martinez, Bill Peck, Judy Roe, Joanne Sandy, Martha Scharfenberg, Steven Squires, Patty Stuckey, and Kay Webber. The images you donated or loaned to the library to use in this book will always be greatly appreciated. All royalties from the sale of this book will go to the Galesburg Public Library. Special thanks to Pat Reyburn for her tireless years of scanning thousands of photographs and negatives. This book would not have been possible without her unselfish donation of time to the library archives. I want to thank library director Harriett Zipfel for her encouragement, patience, advice, and her door always being open. Also to Jane Easterly for her patience, advice, and for allowing me to close the archives the week before the manuscript was due. A special thank-you goes to Luke Gorham: I could not have completed this book without his proofreading, feedback, suggestions, and technical help. I would also like to acknowledge Faith Burdick, who took over my research tasks for the duration of writing this book and for her understanding and laughter. Also, many thanks go to Melinda Rhoades-Jones, whose sense of humor kept me going; Lauren Pierce, for her kindness; and to all of the reference staff who took up the slack when I was entrenched in the book.

I also want to thank my friends who gave me encouragement, laughter, and understanding. They are, in alphabetical order, Sherry Brown, Linda McKelvey, Sandy Peake, Sue Steller, Deb Thompson, and Rose Webb. No one could ask for better friends. Lastly, I want to thank my two sisters, Kathryn Mosher and Jeanne Craig, for their long-distance understanding and reassurance and support. If I have forgotten anyone, I send you my sincerest apology.

Unless otherwise noted, all images appear courtesy of the Galesburg Public Library.

Introduction

When I began thinking about publishing this book, I did so out of a desire to share some of the thousands of amazing photographs that belong to the Galesburg Public Library. While space constraints and donation guidelines limited me to sharing and offering commentary on only a little over 200 of them, I am confident that they achieve what I hoped they would: namely, to tell the story of the "everyman," not to mention everywoman and their children, of Galesburg. This is not a book about all of the great men and women who founded the town, but rather a book for the rest of those who grew up here or have lived here for a number of years and have an interest in Galesburg's past. Many of these images have not been seen for decades, and some are more than 100 years old. I wanted to share them with those who love Galesburg as much as I do.

Many readers probably know those facts of which we are still so proud today, such as the founding of Knox College by George Washington Gale, and recognize names, such as Sylvanus Ferris, Nehemiah Kellogg, and many others that appear on street signs and schools today. Courageous pioneers not only established Knox Manual Labor College, now known as Knox College, but the town of Galesburg as well. Such early residents included the first storekeeper, Chauncey Colton, and the industrious Ferris family. The founders were staunch abolitionists, and Galesburg was an important stop on the Underground Railroad, with members of the town not only hiding runaway African American slaves, but taking them to the next stop on their way north. Abraham Lincoln famously debated Stephen Douglas here. Carl Sandburg was born and raised by Swedish immigrant parents here, and his father, like so many others, came to work for the ever-growing Chicago, Burlington & Quincy Railroad. During the Civil War, Knox County filled its quota of needed soldiers faster than any other county in the state of Illinois, and Mary Ann "Mother" Bickerdyke, supported with donated clothes and food, went onto the battlefields to rescue injured men and take them to sanitary makeshift hospitals. These are important people and events in the town's shared history, but they are not the entire story.

My goal for this book was not to explore these more celebrated figures of Galesburg, but to produce a history of the town that immediately triggers a memory for readers or makes them smile at the way people lived long ago. It is meant to be a book that shows in photographs how ordinary citizens were pivotal in shaping Galesburg, just as much as its more famous denizens.

Galesburg has been called "College City," "Tree City USA," and "All-American City." I hope to convey, through the images in this book, the spirit of these nicknames. During the years when the factories were going strong and people had money to spend, businesses thrived and jobs were plentiful. Crops were good, and someone even wrote a song about Galesburg, "Buckle on the Corn Belt." Many thought this good fortune would go on forever. Of course, Galesburg had problems back then, too. But there is a special nostalgia reserved for hometown childhoods, and Galesburg certainly provided many residents with a lot of good to remember. A *Facebook* group, "Remember in Galesburg When," has more than 5,000 members, sharing photographs and memories of the town. There are reminisces about visiting the stores, roller-skating at the rink on Grand Avenue,

riding bikes with a clothespin and a playing card in the spokes, and playing a pickup game of baseball. There is talk about playing under streetlights, attending proms, going to county fairs, cruising Main and Henderson Streets, seeing the first searchlights of the summer at Kiddieland amusement park, and catching fireflies. There are also memories of favorite restaurants, having a frosty root beer at the A&W, and when older having a beer at one of the local watering holes.

That is the story I want to tell. It is about everyone who lived, worked, played, and prayed here. One of my favorite memories is hearing the long, low whistle of a train in the summertime. That is what I hope I have accomplished with this volume—to have delivered a little bit of home to readers and helped them recall long-cherished memories. This is for those who miss those days, no matter what their favorite decade was. Some of the photographs are from a time when everyone who was here are now long gone, a time when everyone worked together to make Galesburg what it was and what it still is, a great town beloved by all who grew up here.

With the first chapter, "Galesburg: All-American Town," I hope to present a portrait of small-town American life and celebrate the people who made up the fabric of Galesburg through the years. For the last chapter, "Recreation and Culture: Why We Love the Burg," I chose to include photographs of some of the fun that has been had in Galesburg over the years, ending the book on what I hope is a joyous note.

Some people say that Galesburg is not what it used to be, but every town is constantly changing. It is the cyclical nature of life, and, as in all things, change is not inherently bad. Personally, I believe that Galesburg is still a great town with a promising future, and one of the clearest ways to see that is to remember its past. In these pages, I hope to show what went in to the forming of the town and that what residents do today still makes a difference.

So, dig in and take a trip back home to Galesburg. It is not far—it is just as close as these pages and personal memories. These images of the town may trigger memories of sounds, like that train whistle, or a favorite top-40 song on a transistor radio at the beach. It could be kids shouting and laughing in the water, the smell of suntan lotion, and the feel of sand under one's feet. A photograph may evoke older memories, maybe of walking into O.T.'s and smelling a combination of freshly mixed face powder and those wonderful doughnuts frying in the back, just waiting for a sprinkling of powdered sugar, or of caramel corn popping on Main Street, or the way a Popsicle tasted on a hot summer day. It is all right here, waiting to be explored. The reader is invited to take a look and travel back—back home to Galesburg.

One

GALESBURG

THE ALL-AMERICAN CITY

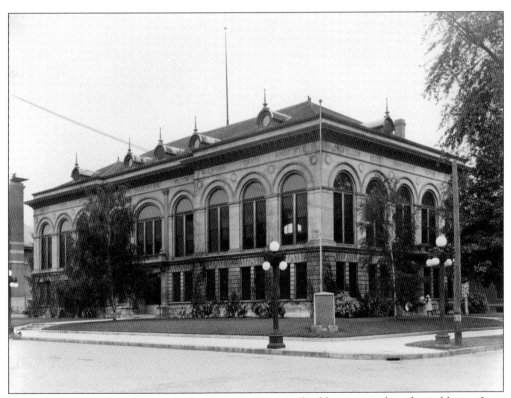

GALESBURG CARNEGIE LIBRARY. This three-story stone building opened to the public on June 3, 1902, with a number of speeches given before the doors opened. It began as the Young Men's Literary Society in a second-story building on Main Street in 1858. This library caught fire on May 9, 1958, due to a short circuit in an attic fan. The structure was completely destroyed because of lack of water to extinguish the blaze.

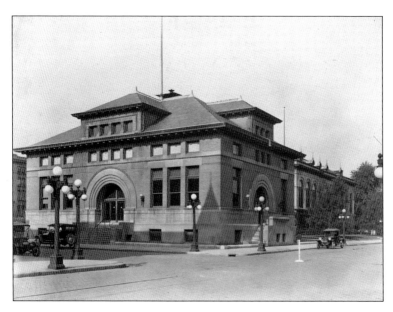

US Government Building. Located on the northeast corner of South Cherry and East Simmons Streets, this building was erected in 1894 and housed a variety of government offices and the post office. In 1936, when a new post office opened on Main Street, this structure sat empty. It later served as a very successful youth center for several years.

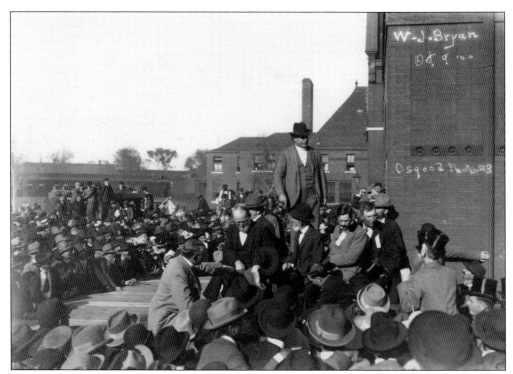

William Jennings Bryan. On September 7, 1896, William Jennings Bryan arrived in Galesburg aboard a Chicago, Burlington & Quincy train and stood on a platform at the depot and gave a speech. Bryan made hundreds of stops in different cities while running for president, and he swayed many people, including a young Carl Sandburg, to vote for him. Bryan lost the election to William McKinley.

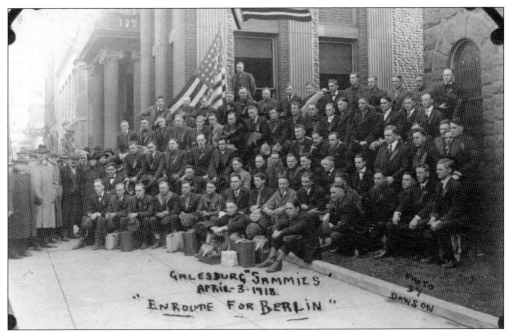

WORLD WAR I SAMMIES. This photograph shows just a handful of the first men from Knox County who were drafted to fight in Europe. They are heading for boot camp in April 1918. American soldiers were called "Sammies" by French soldiers, based on the Uncle Sam posters. Over 100 men from Knox County died during World War I. It is not known how many were maimed or wounded.

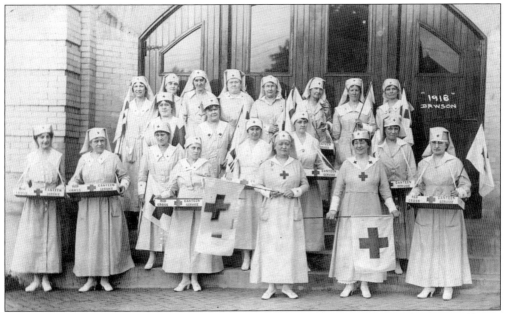

RED CROSS VOLUNTEERS. Hundreds of Knox County women wanting to help during World War I volunteered for the Knox County chapter of the American Red Cross. Not only did they roll surgical bandages and knit warm clothing for soldiers, they also met and helped over 95,000 men who were going to war, changing trains, or coming home. This experience enabled them to help during the influenza epidemic of 1918.

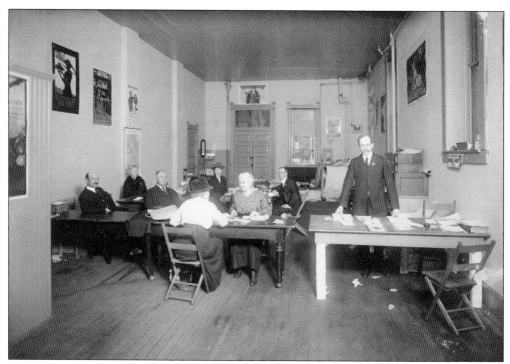

KNOX COUNTY COUNCIL OF NATIONAL DEFENSE. This national association formed during World War I to coordinate resources and industries and to support the war effort. Among the resources given support were farm and industrial production, public morale, and financial aid. The council was disbanded in 1921. The exact location of this office is unknown except that it was in Galesburg.

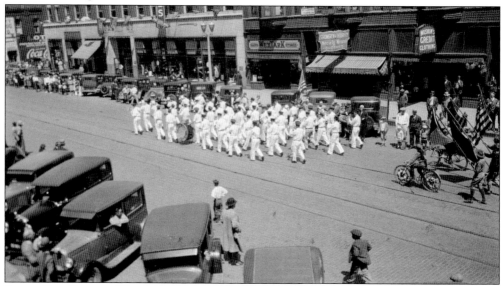

LABOR DAY PARADE. This early-1930s photograph is believed to show a Labor Day parade as a marching band passes by. At right, Boy Scouts ride bicycles and carry flags. Stores seen here are Kline's Department Store in the Bondi Building, Wextrak Radio Store, Stromgren & Thoureen Clothing, and Moskin's Credit Clothing.

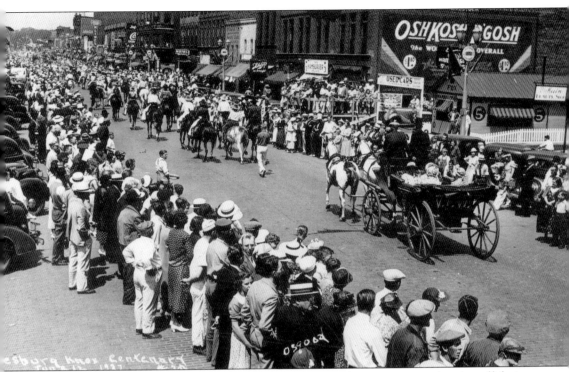

CENTENARY PARADE. On June 12, 1937, these centenary parade entrants were showing off their costumes and horses. The parade moved west, from Chambers Street to the Public Square, where a Ferris wheel was set up. The crowd, five deep, watched all of the glory and hoopla. Parades were well attended before the widespread use of television.

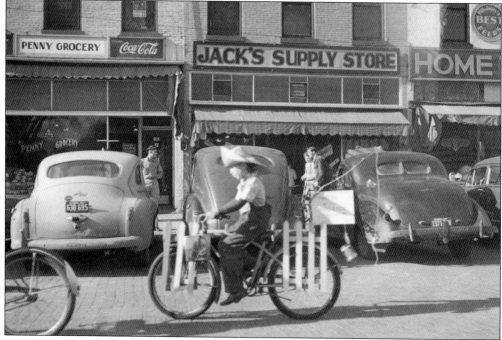

TOM SAWYER AT THE SQUARE. This young man has decked out his bicycle into a moving scene from *The Adventures of Tom Sawyer* for a 1947 parade. Attached to the bike is a white-washed fence, and a fishing pole is in the back. He is riding in front of the Penny Grocery and Jack's Supply Store, located on the northeast side of the Public Square. (Courtesy of the Ray M. Brown family.)

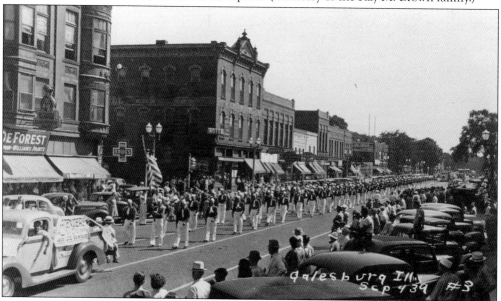

LABOR DAY PARADE, 1939. Proudly stepping down East Main Street on September 4, 1939, are members of the United Brick and Clay Union Local 405 of the American Federation of Labor. These employees of the Purington Paving Brick Company in East Galesburg stretch more than the length of a city block. Just in front of them is the Bartender's Union truck; the Purington men certainly put them to shame.

JAYCEES ARMORY HOME SHOW. From June 4 to 6, 1948, residents could feast their eyes on the latest items for the home. Packed with buyers and those just looking, the home show offered a glimpse of how one could turn a home into a showplace with new furniture and a more-efficient household with new time-saving appliances.

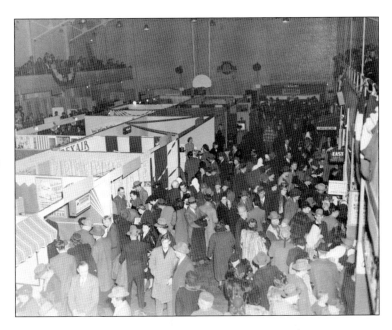

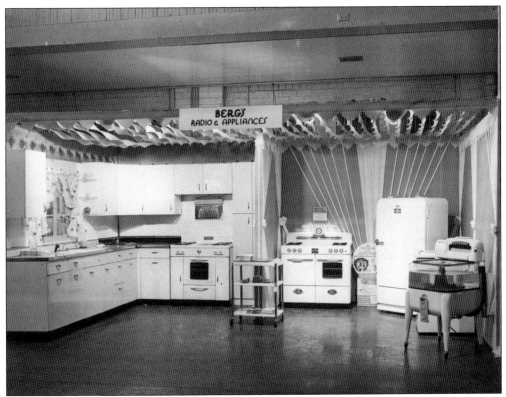

JAYCEES HOME SHOW. A kitchen full of appliances is what Berg's Radio and Appliances showed visitors at the 1949 Galesburg Jaycees Home Show. It was what retailers thought would be every woman's dream. After World War II, the nation experienced a building boom, and home shows gave families ideas about what they wanted in their homes.

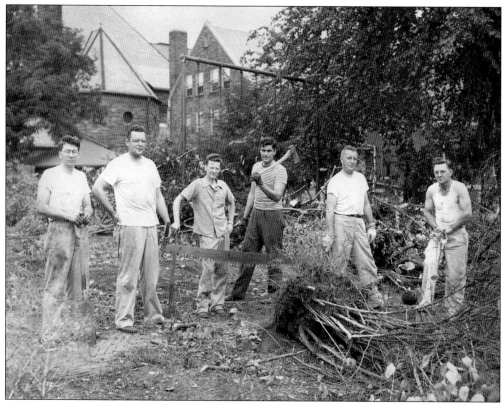

JAYCEES LEND A HAND. In an act of selflessness, the Galesburg Jaycees spent several weekends clearing 10 trees, 200 shrubs, and other unwanted vegetation, as well as 350 feet of old fencing at an abandoned lot next to the Free Kindergarten Orphanage on Simmons and Cedar Streets. They then brought in playground equipment and built a picnic shelter and basketball hoop. The Jaycees believed that happy children would grow up to be good citizens.

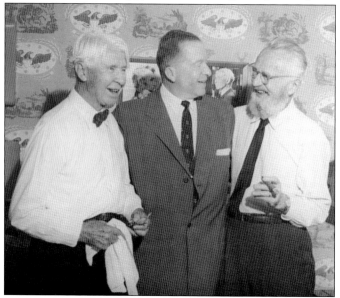

SANDBURG AND STEICHEN. During the 100th anniversary of the Lincoln-Douglas debate in Galesburg in 1958, "everyman" and native son Carl Sandburg and his wife, Lillian, came back to celebrate. Upon arriving at his suite at the Hotel Custer, Sandburg's brother-in-law, photographer Edward Steichen, burst out of the bathroom with a photographer to surprise him. Here, Sandburg (left), hotel manager Bernard Schimmel (center), and Steichen enjoy the surprise. (Courtesy of the Dale Humphrey family.)

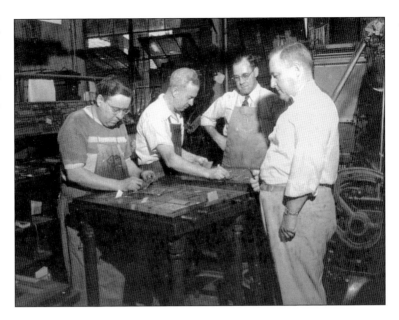

GALESBURG REGISTER MAIL NEWSPAPER. Nothing could be more American than the Constitution's guarantee of freedom of the press. Here, typesetters at the *Galesburg Register-Mail* newspaper put in advertisements for that evening's edition. Their identities are not known. (Courtesy of the Dale Humphrey family.)

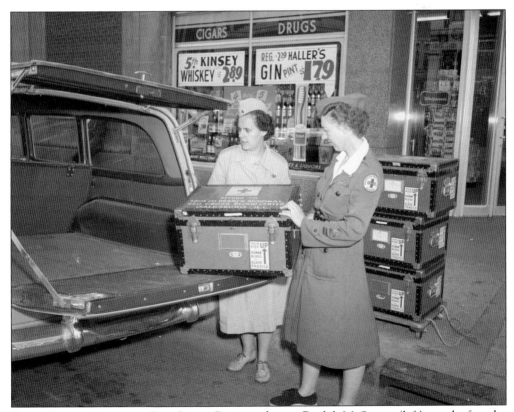

KNOX COUNTY AMERICAN RED CROSS. Registered nurse Beulah M. Strong (left) was the founder and director of the Knox County American Regional Red Cross Blood Center. She is loading blood into a station wagon outside of Walgreens Drug Store on the southwest corner of East Main and Prairie Streets. The station wagon was donated by the employees of Butler Manufacturing.

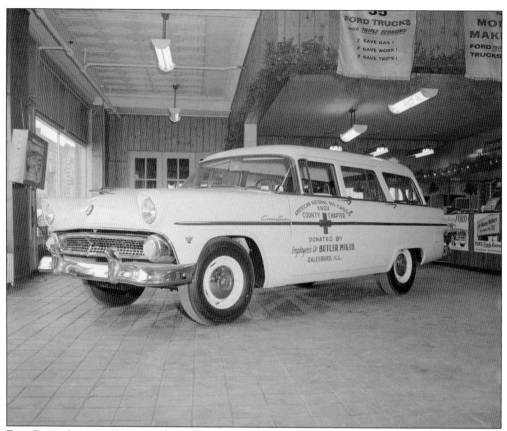

RED CROSS STATION WAGON. This station wagon was purchased new from a Galesburg automobile dealer for the Knox County chapter of the American Red Cross blood bank. Donations were given over time by employees of Butler Manufacturing.

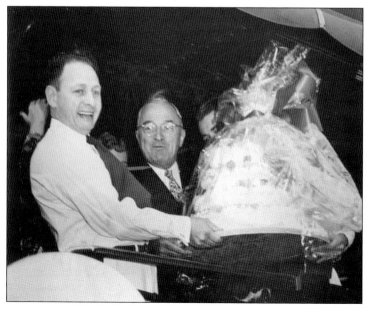

TRUMAN WHISTLE-STOP TOUR. Pres. Harry Truman (center) receives a birthday cake from a local baker during his stop at the CB&Q station in Galesburg on May 8, 1950. It was one of 50 stops he would make over 10 days on his way to the Pacific Northwest to support fellow Democrats during their election campaigns.

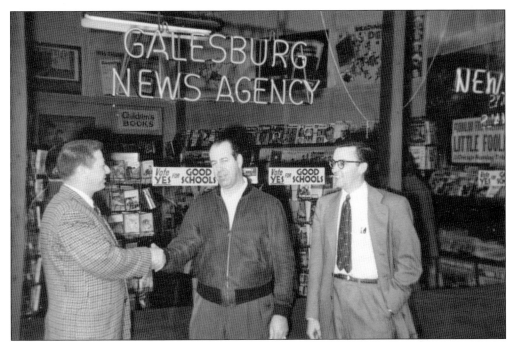

CRIME PREVENTION WEEK IN GALESBURG. In 1955, during National Crime Prevention Week, the Exchange Club joined forces with businesses to "eradicate odious juvenile publications," seen as an impetus of adolescent misbehavior. "Vulgar and objectionable" comic books featured slang, crime, science fiction, and magic. Dave Feldman (center), owner of the Galesburg News Agency, agreed to censor all materials that he sold to Galesburg retailers. Also seen are Exchange Club president Roderic Howell (left) and David Ruedig. (Courtesy of the Galesburg Exchange Club.)

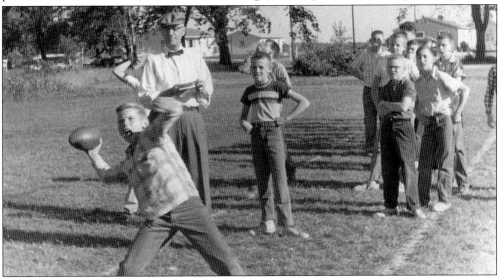

JUNIOR OLYMPICS. On May 28, 1958, the eighth-annual Junior Olympics Field Day was held, sponsored by the Galesburg Exchange Club. In all, 275 boys competed for athletic glory. It was held after school at the Lombard Junior High School sports field. All boys aged 13 and younger who were attending District 205 schools were eligible to compete. (Courtesy of the Galesburg Exchange Club.)

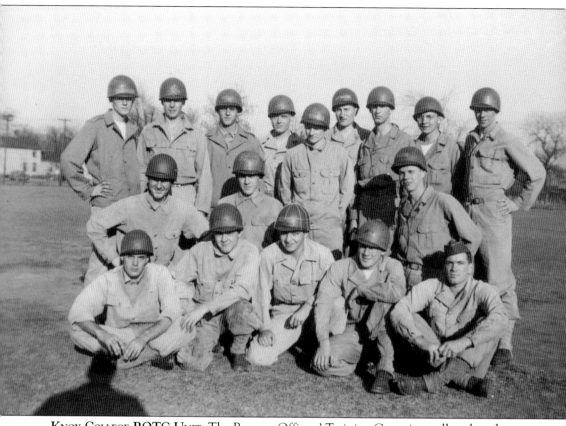

KNOX COLLEGE ROTC UNIT. The Reserve Officers' Training Corps is a college-based program for producing commissioned officers. There are no visible landmarks to date this photograph of Knox College ROTC members, but the helmets and gaiters worn by these men indicate that it is either before or during World War II.

Two

Businesses
The Door to Opportunity

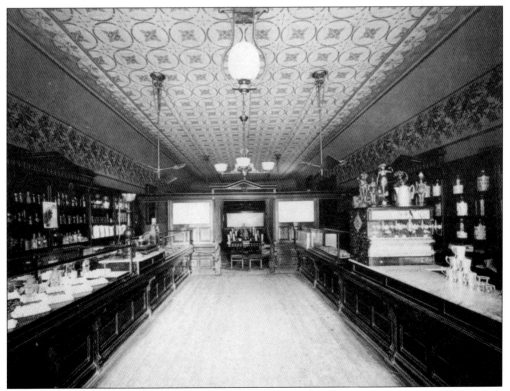

F.G. Burtt's Restaurant and Confectionery. Located at the southeast corner of East Main and South Cherry Streets, this gem of a building had a candy counter (left) and a soda counter (right). Jars of candy were displayed behind each counter on carved wooden shelves. In the back of the restaurant is a small, separate dining-room area. This photograph was taken around 1893.

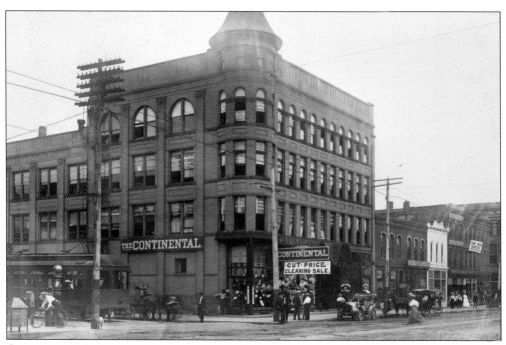

CONTINENTAL CLOTHING STORE. Continental Clothing opened a small store on East Main Street in 1895, but after a year it moved to larger quarters in the Holmes Building (pictured). Savvy businessman Sam Stern was the first owner. He found success in offering quality clothes at one low price. In 1908, the Holmes Building burned down, but Continental Clothing has continued in different locations over the years.

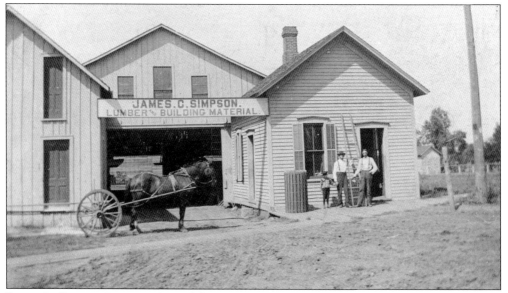

JAMES C. SIMPSON LUMBER. One of these men is James C. Simpson, standing proudly in front of his lumber yard that he purchased from Norman Anthony around 1894. Located at 340 East South Street, it was one of Galesburg's most successful enterprises, operating for about 100 years. Besides lumber, it sold shingles, cement, lime, and coal. It is remembered by many today as Simpson–Powelson Lumber Yard, which closed sometime in 1989.

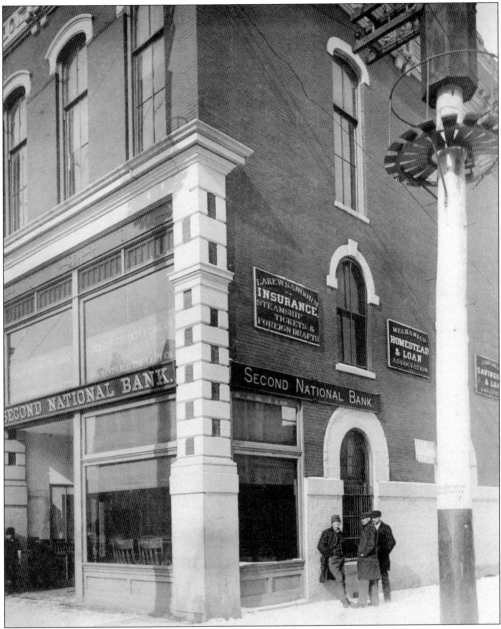

SECOND NATIONAL BANK. This bank opened sometime in the 1870s at 15 East Main Street, and it closed prior to 1907. While it was solvent, some well-known men were officers in the bank, including O.T. Johnson, James Losey, Henry Hitchcock, and Alfred Knowles. An advertisement stated the bank had a capitol surplus of $150,000, which amounts to about $3.6 million today.

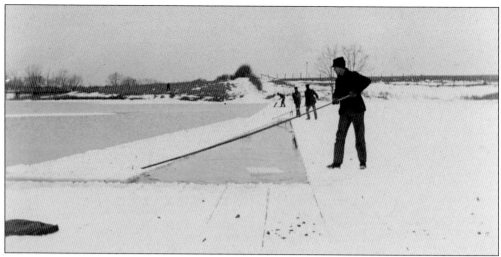

ICE HARVESTING. It is harvest time, and these men are working on Lake George. Horses first scored the ice, then men sawed the ice into large cakes, which were then floated to a big icehouse. Carl Sandburg worked at this job in the late 1890s. When stacking the big cakes, he stopped for a few minutes to rest. The foreman told him, "Better slide into it, Sandburg."

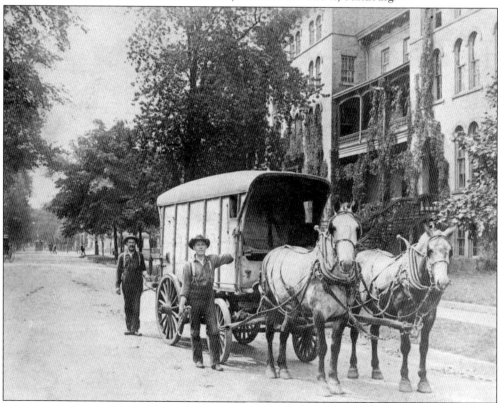

GLENWOOD ICE COMPANY. Before electricity, iceboxes were essential to keep food fresh. Delivery wagons carrying ice harvested from Lake George were a common sight. Numbered signs were placed in the windows of homes, indicating if ice was needed and how many pounds. The big slabs of ice were then picked up with tongs and carried to the house.

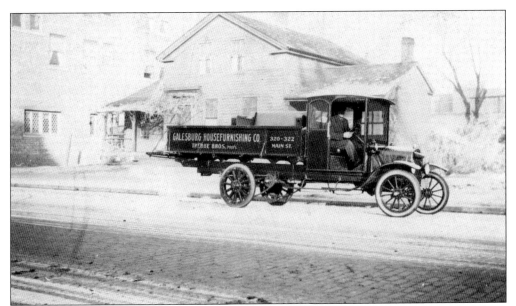

GALESBURG HOUSEFURNISHING COMPANY TRUCK. Opened about 1905, the Galesburg Housefurnishing Company, at 320–322 East Main Street, sold furniture, carpets, gas stoves, and coal ranges. Owner F. Albert Trebbe brought his sons Albert Jr. and Henry into the business. The store remained open until around 1935. The location of this photograph is not known. (Courtesy of Patty Stuckey.)

JAMES L. BURKHALTER. Born in Pennsylvania, Burkhalter moved to Knox County, attended Knox College, and then studied law. He worked in the lumber and building business and was a major in the Civil War. After, he had stock in the Farmers & Mechanics Bank and was elected bank president, serving there for 25 years. He is seen here at the bank in 1907. Burkhalter died in 1908. (Courtesy of James and Judy Allen.)

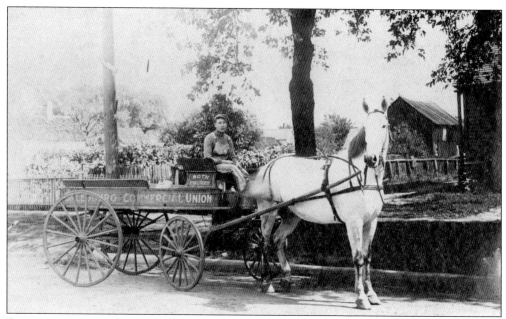

COMMERCIAL UNION DELIVERY WAGON. As with ice, most grocery stores delivered groceries on demand to busy housewives, who could call in an order and get it the same day. The driver, Les Hartman, and his trusty steed no doubt delivered orders each day from the store, located at 301 East Main Street. This photograph was taken in 1910.

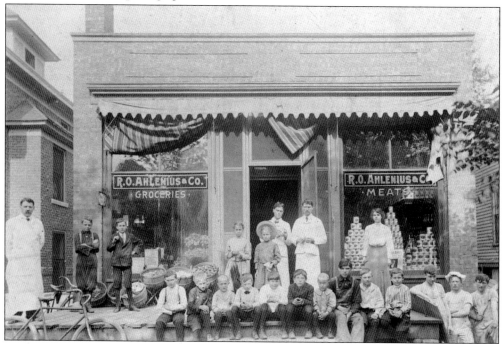

AHLENIUS & COMPANY GROCERIES. Neighborhood grocery stores are long gone, with only a few empty buildings left standing as reminders. But, in 1928, there were 134 of these small wonders in town. Besides food, they carried a little bit of everything one needed to keep house. This 1912 photograph shows Ahlenius & Company at 977 East Main Street.

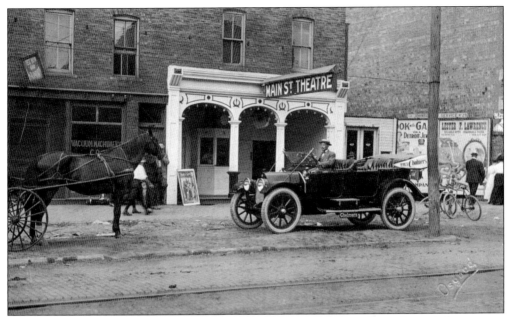

MAIN STREET THEATRE. Not much is known about this theater, except that it showed silent movies and was located at 427 East Main Street. The movie being shown that week was *The Heart of a Gypsy*. Galesburg had many theaters that came and went quickly, so it is fortunate to have this photograph. The automobile is the new 1913 Chalmers touring car.

HORSESHOE CAFÉ. Just off of the Public Square was a jaunty sort of restaurant that was a favorite of Knox College students and vaudeville performers. The restaurant, near campus and the Auditorium Theater, had good food at good prices, a cafeteria, a dining room, and a second-floor hotel. Performers often gave impromptu performances around the piano in the dining room after dinner. This photograph was taken around 1918.

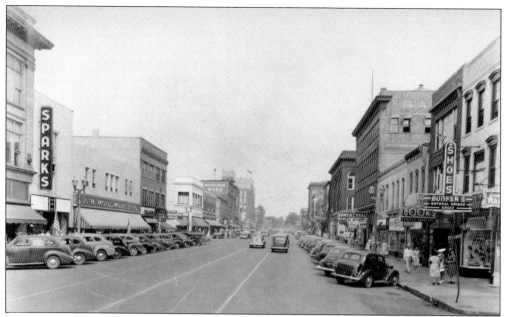

DOWNTOWN GALESBURG. This downtown scene, probably from the 1930s, shows diagonal parking. Bunker Shoes (right), one of the oldest businesses in town, opened in 1876. Sparks and F.W. Woolworth are on the left. A feeling of nostalgia is evoked in this photograph of Galesburg's wonderful old Main Street, when business was good and most people shopped there.

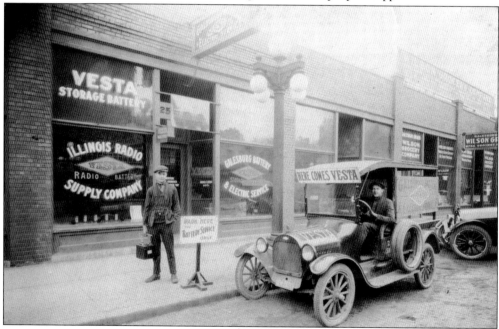

GALESBURG BATTERY & ELECTRIC SERVICE. The man sitting behind the wheel of the truck is the proprietor, Harold F. Berg; his vehicle advertises Vesta Batteries. Located at 258 East Simmons Street, this business sold batteries for electric automobiles and for radios whose owners lived out in the country, as many rural areas had no electric service at the time of this 1923 photograph. (Courtesy of the Berg family.)

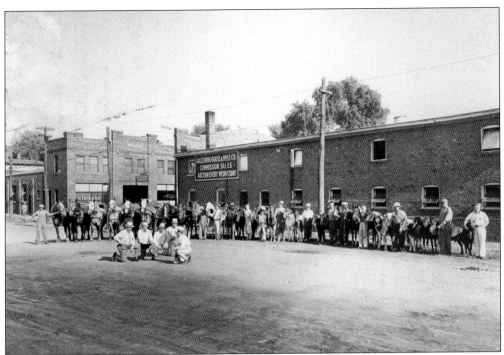

GALESBURG HORSE & MULE COMPANY. Known for many years as the Marsh Sale Barn, or the Mighty Horse Market, the auction company was located at 188 North Cherry Street. Auctions were held weekly, and thousands of horses were sold each year. This was one of the largest sale barns in the country. Business was especially brisk during World War I, when European agents bought war horses. This image was taken around 1920.

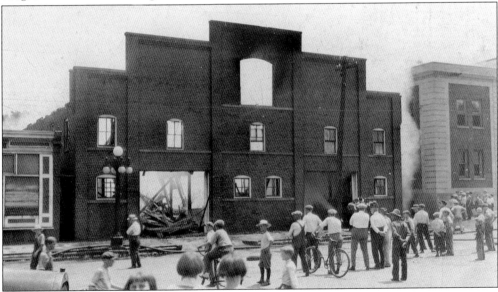

GALESBURG HORSE & MULE FIRE. On July 7, 1923, the Galesburg Horse & Mule Company was destroyed by fire. Located at 188 North Cherry Street, the buildings extended the entire block from Cherry to Broad Streets. It was rebuilt, and horse auctions continued there until it filed for bankruptcy. All real and personal property were auctioned off in January 1938.

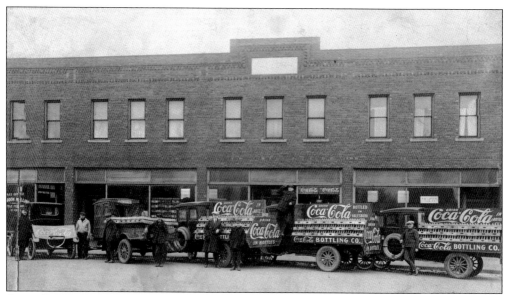

COCA-COLA BOTTLING PLANT. Located at 401 East Berrien Street, the Galesburg Coca-Cola bottling plant mixed and bottled the famous soft drink for several decades. These men, standing next to their trucks in 1923, are ready to deliver the familiar green bottles to stores, restaurants, and other vendors.

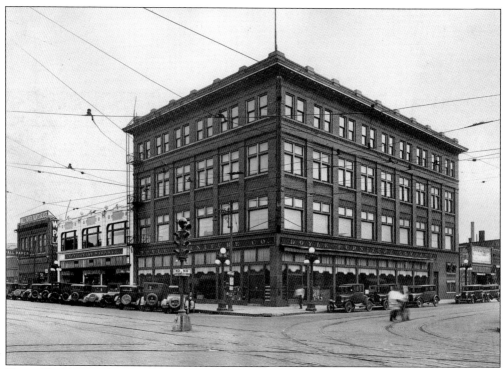

DOYLE FURNITURE COMPANY. Located on the southeast corner of East Main and South Seminary Streets, this store was owned by William E. Doyle and his brother F.A. Doyle. The establishment sold more than furniture, with 42,000 square feet of goods, including stoves, china, cut glass, draperies, bedding, and carpeting. The building is now the home of Lindstrom's Appliance Store.

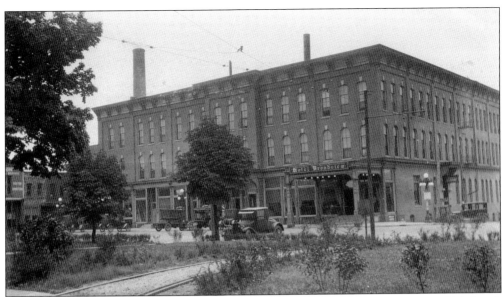

HOTEL BROADVIEW. Built in 1871 as the Union Hotel, this establishment was at one time Galesburg's finest hotel, with 150 rooms and many amenities. Prior to this 1926 photograph, it had become the Hotel Broadview. In the foreground can be seen what looks like a walking path, but it is actually trolley tracks going through the Public Square.

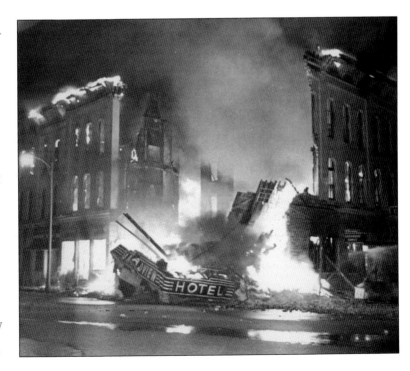

BROADVIEW HOTEL FIRE. This image shows the rather sad end to the Union-Broadview Hotel in 1969. Once a building of beauty and charm, it had spent the last 50-plus years going downhill. Due to urban renewal, its destruction was planned for July 1969. But, due to an undetermined source, fire destroyed the old building on June 21, 1969. (Courtesy of the Dale Humphrey family.)

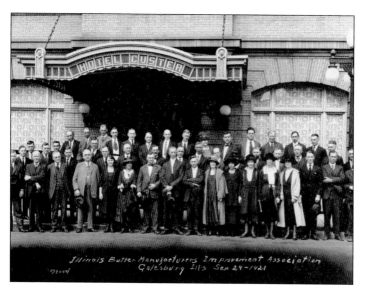

BUTTER CONVENTION. These men and women are standing in front of the Hotel Custer to attend the Illinois Butter Manufacturers Improvement Association convention on September 29, 1921. This meeting of creamery folk was written about in the *Butter, Cheese and Egg Journal*. One of the highlights was a dairy luncheon at the Pioneer Creamery, located at 126 South Chambers Street.

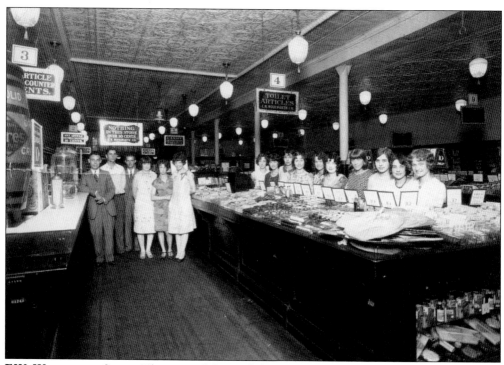

F.W. WOOLWORTH STORE. The original five-and-dime store made its debut in Galesburg around 1912. Located at 143 East Main Street, it carried a little bit of everything and was much like the dollar stores of today. This store for the frugal shopper closed its doors around 1960. The photograph was taken in the mid-1920s.

Swanson Grocery Store. This store is larger than the smaller neighborhood grocery stores in town, but the same personal service was offered with the advent of grocery carts still a few decades away. The clerk would read a customer's list and retrieve the wanted items. This store has a sign for Old Heidelberg Malt, dating the photograph sometime after Prohibition ended. This is now the location of Calico Cat Gift Store.

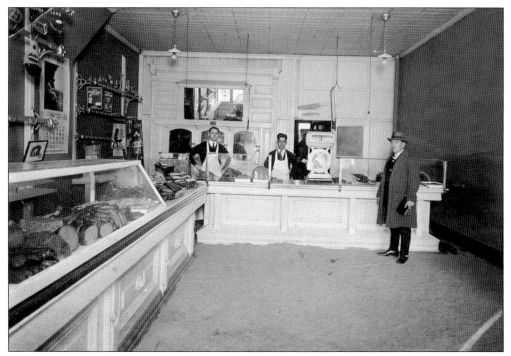

Charlson's & Son Meat Market. Located at the northeast corner of North Broad Street and the Public Square, this butcher shop was established in 1879 by John Charlson. This 1920s photograph shows sawdust on the floor. Located behind the store was a six-ton refrigerated meat locker. The men behind the counter are believed to be C.T. Charlson (left) and Fred McNamara.

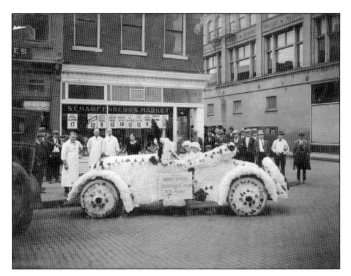

SCHARFENBERG'S MARKET. Shown is the grand-opening celebration at Scharfenberg's Sanitary Meat Market around 1925. The establishment was located at 130 East Main Street. The decorated car and the two pretty young women in it have attracted several members of the male population in the downtown area. Among the items on sale were choice cuts of beef at 13¢ per pound. The motto of the store was "Good meats since 1876."

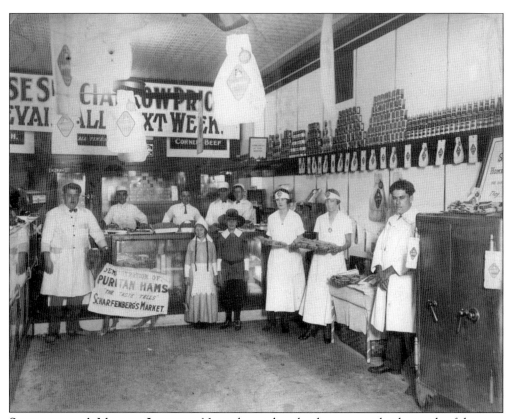

SCHARFENBERG'S MARKET, INTERIOR. Not to be outdone by the car outside, the inside of the store had plenty to display as well, including two children costumed as pilgrims. Sample ham sandwiches are being offered by two ladies wearing flapper headache bands, and a dog wears a full-length banner advertising Puritan Hams. In addition, Puritan Ham bags hang from the ceiling.

ECONOMY SHOE STORE. Employees of the Economy Shoe Store look ready to help customers find the right size and style of shoe in the 1930s. The store was located in the basement of the First Galesburg National Bank building. These employees are leaning against the railing of the stairs leading down to the store. There were many basement businesses in Galesburg at one time, but they are now gone.

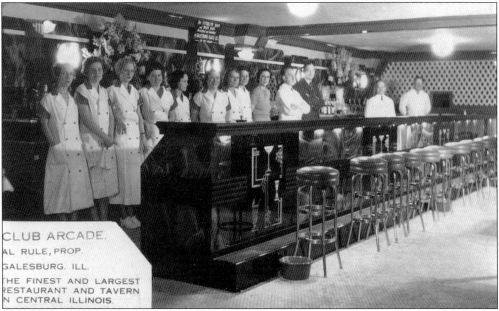

CLUB ARCADE. Located in the basement of the Weinberg Arcade, this Art Deco café opened in 1936. The bar area is decorated with Vitrolite glass, provided and installed by the Galesburg Glass Company. This gave the establishment the streamlined look that was so popular in the 1930s. The restaurant boasted that it was the finest and largest restaurant and tavern in central Illinois, but it remained opened for only one year.

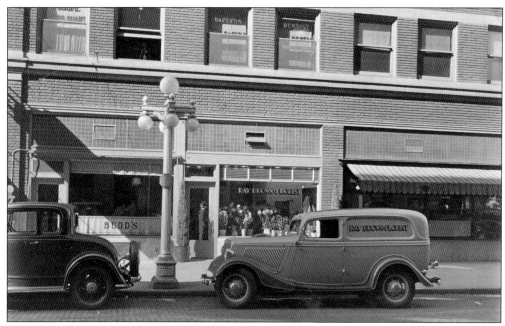

RAY BROWN FLORIST. Located on the Kellogg Street side of the Hill Arcade building, the Ray Brown Florist shop had something very unique to make the store memorable: a bright purple delivery truck. Here, the famous truck is parked in front of the flower-filled store around 1935. The purple truck was driven to Chicago about once a week to purchase fresh flowers at a wholesale flower market. (Courtesy of the Ray M. Brown family.)

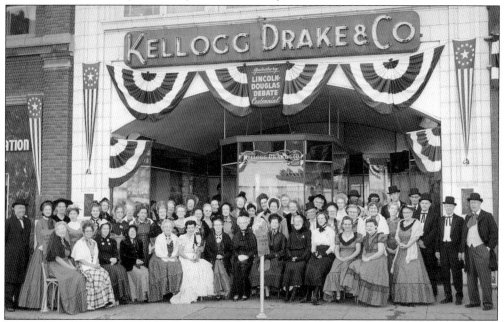

KELLOGG DRAKE & COMPANY. This 1958 photograph was taken in conjunction with the 100th anniversary of the Lincoln-Douglas debate in Galesburg that took place on the campus of Knox College. Many people attended the reenactment and were encouraged to dress in the fashions of that time. The proud employees of this store can be seen taking it to heart.

PETER NELSON BUILDING. In 1886, Peter Nelson built this three-story corner building to house a grocery store. He rented out the upper rooms to other businesses. In 1915, Nelson retired, and the unimpressive Main Hotel took over the two top floors, with Ericson & Larson Grocery on the first floor. In 1946, Black Brothers Hardware store moved in and remained in that location for 34 years. (Courtesy of Charles Osgood.)

KNOX COUNTY OIL COMPANY. This business was known for delivering oil and gasoline to farmers from its main location on Monmouth Boulevard. The service station seen here was located at 95 North Seminary Street. It sold Aladdin gasoline, "the magic power fuel." Gasoline was priced at 20¢ per gallon—in today's money, about $3.30. Shown here around 1940 are, from left to right, Harold Jewsbury, two unidentified men, and Lawrence "Ike" Fisher.

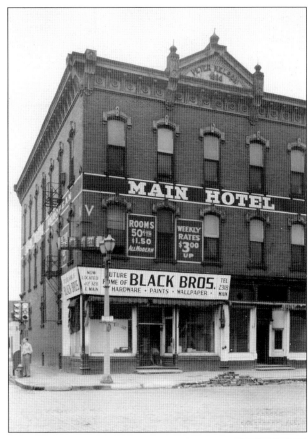

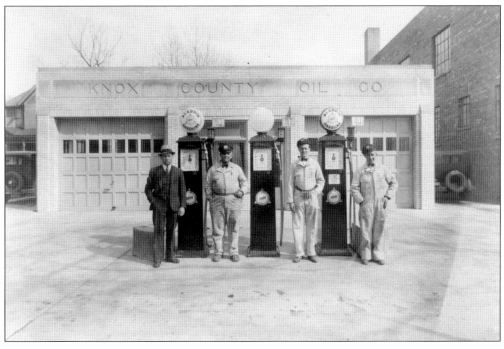

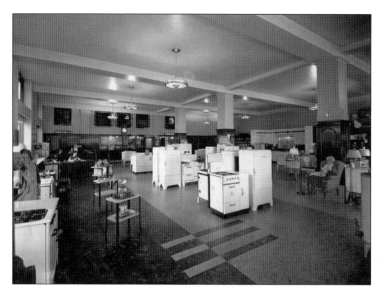

ILLINOIS POWER & LIGHT COMPANY. Sometime in the 1930s, Illinois Power & Light Company began selling appliances, as well as electricity, to its customers. On the first floor, an amazing variety of stoves, refrigerators, fans, toasters, and other new time savers were on display to tempt customers as they walked to pay their bill at the cashier's window at the back of the store.

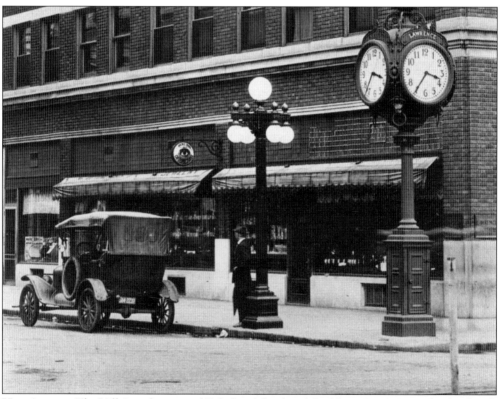

HILL ARCADE. The Hill Arcade is one of Galesburg's landmark buildings. In 1919, another landmark was installed there by Lawrence Brothers Jewelers: a four-faced, 3,000-pound Seth Thomas clock, fondly known as Big Ben. The clock remained on the corner until 1937, when some joyriding youths crashed into Ben and destroyed it, and their automobile. The clock was never replaced, as officials deemed it a hazard to drivers.

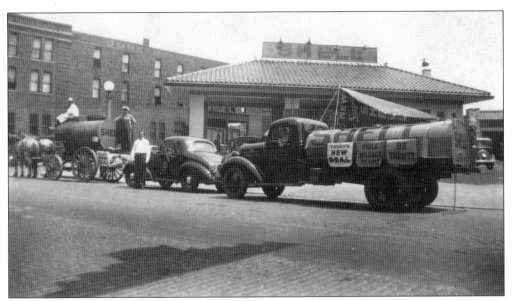

KENNEDY SERVICE STATION. This photograph was taken after the Galesburg Centenary Parade on June 12, 1937. Owner Edward Kennedy had three vehicles in the big parade, advertising Shell gasoline. Shown from left to right are an antique or reproduction horse-pulled tank wagon, an automobile, and a 1930s tanker truck advertising his business, located on the corner of South Seminary and Mulberry Streets. The motto of his station was "more power to you."

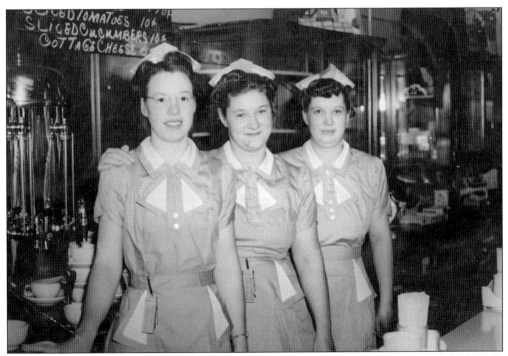

WARREN'S LUNCH. How about a cup of joe? These three waitresses at Warren's Lunch look ready to fill cups for customers from the coffee urn behind them. Located at 62 South Kellogg Street, Warren's was only open in 1943. The waitress on the right is Maxine Carroll Thomas.

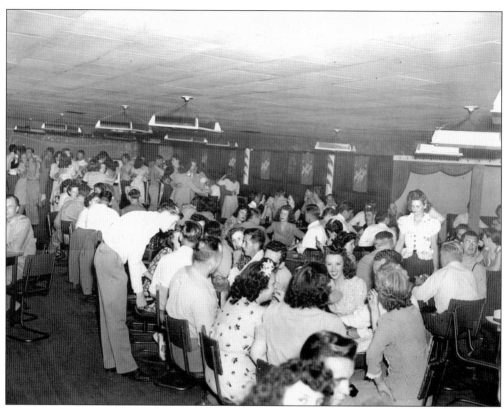

HARBOR LIGHTS. This is the interior of the first Harbor Lights supper club, when it was located near Lake Storey. The wooden building had sides that could fold down during the summer. It was opened during the Great Depression by the Mangieri brothers. People came not only to eat a fine dinner, but also to hear live bands and to dance. The restaurant burned to the ground in the mid-1940s. (Courtesy of the Mangieri family.)

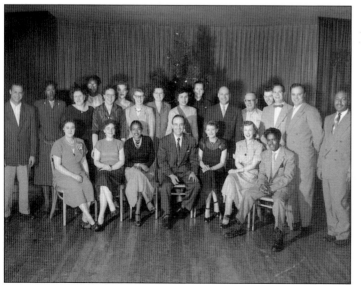

NEW HARBOR LIGHTS. After the fire at the first Harbor Lights, a new and finer supper club was opened that set the standard for restaurants in Galesburg. Its unique design by architect Don Gullickson made it the chic new bistro to beat, with fine food and excellent service by the friendly staff and owners. It was a favorite for many years. This photograph was probably taken in the early 1950s. (Courtesy of the Mangieri family.)

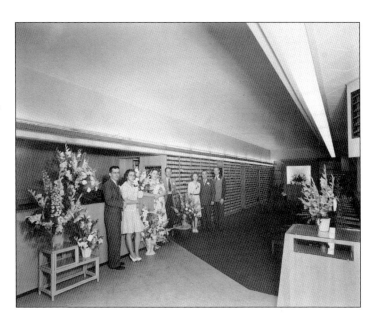

TED GROTHE SHOES. Shown here is the grand opening of the Ted Grothe shoe store sometime in the 1940s. The store sold fashionable and orthopedic shoes and, like other shoe stores, it offered the use of a shoe-fitting fluoroscope—basically, an X-ray machine. Kids loved to place their feet in them so they could see their toe bones. It was removed sometime in the 1960s. (Courtesy of Ted Grothe Jr. and the Grothe family.)

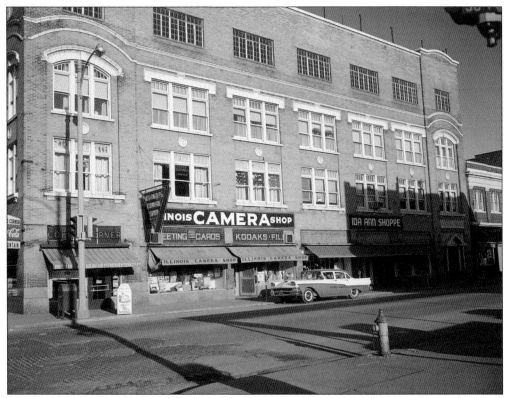

ILLINOIS CAMERA SHOP. Opening around 1922 on East Main Street, the Illinois Camera Shop moved to the Weinberg Arcade at 84 South Prairie Street and remained there until 1966. Besides selling cameras and developing still and motion-picture film, owner Charles Fach sold pens, stationery, and art and party supplies. Just to the right was the Ida Anne Shop, which sold upscale ladies' wear. (Courtesy of William Gliessman.)

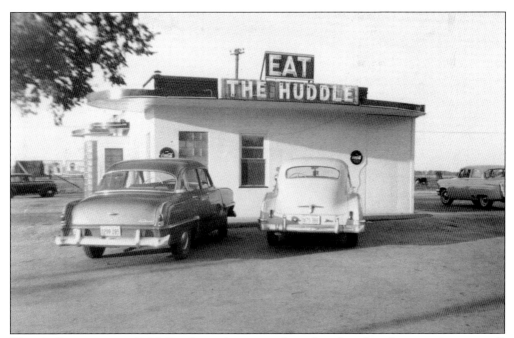

HUDDLE RESTAURANT, 1946. It takes only two words to describe what drew people to a small burger joint that opened on the outskirts of Galesburg in 1946: good food. Over the years, owner Paul Peck kept enlarging his business and the menu to become the first drive-in restaurant in the area and a teen favorite. (Courtesy of Bill Peck.)

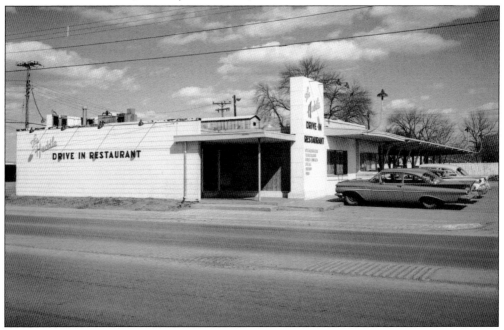

HUDDLE RESTAURANT, 1960. This photograph of the Huddle shows the building that most residents remember. Beyond the cars is the drive-up area. Paul Peck continued to grow his establishment over the years to include a family restaurant, a banquet room, and a cocktail lounge. The Huddle closed in 1996. (Courtesy of William Gliessman.)

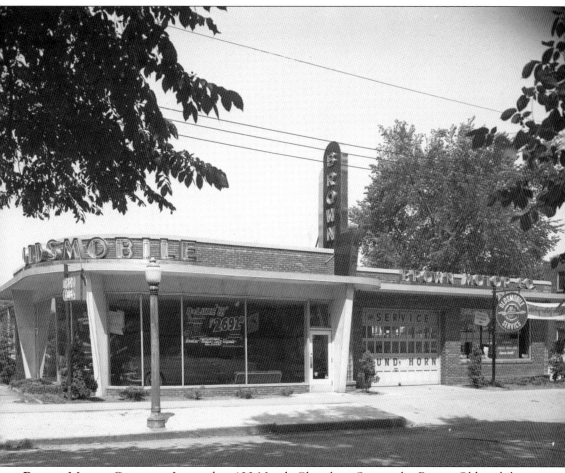

BROWN MOTOR COMPANY. Located at 120 North Chambers Street, the Brown Oldsmobile dealership, owned by Henry Brown, offered "the key to a thrilling ride"—note the Oldsmobile Rocket Car in the window. The new Oldsmobile features included a Hydromatic three-speed transmission, radio, turn signals, and oil filter. It cost $2,692; with inflation, that would be about $26,000 today. This photograph was taken in 1949.

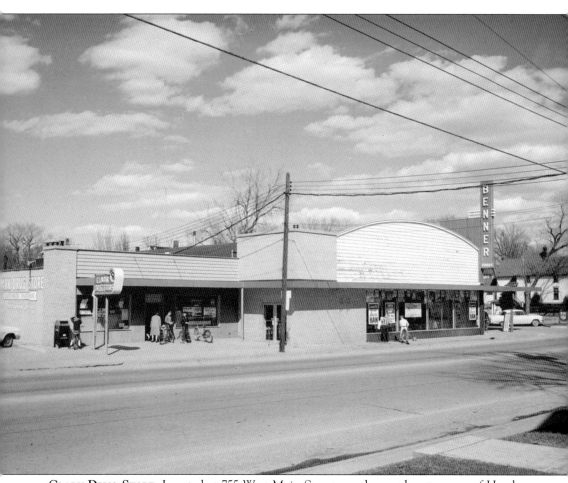

CLARK DRUG STORE. Located at 755 West Main Street, on the northeast corner of Henderson and Main Streets, the Clark Drug Store is probably best remembered for its friendly service and delivery Jeep. Attached to the roof of the vehicle was a replica mortar and pestle. This photograph was taken during the pharmacy's grand-opening week, sometime in 1958. (Courtesy of William Gliessman.)

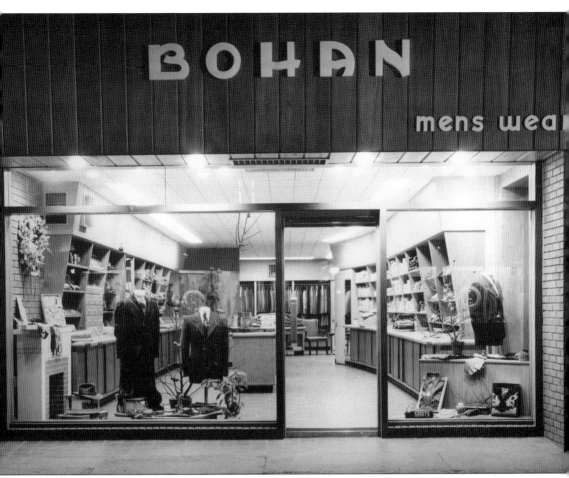

BOHAN MEN'S WEAR. Located where Park Plaza now exists at 130 East Main Street, Bohan clothing store carried a wide variety of fine men's suits and hats. The interior was designed by esteemed local architect Don Gullickson, and his touch can be seen in the sharp, clean lines in the store that were so popular in the late 1950s and 1960s. (Courtesy of Enid Hanks.)

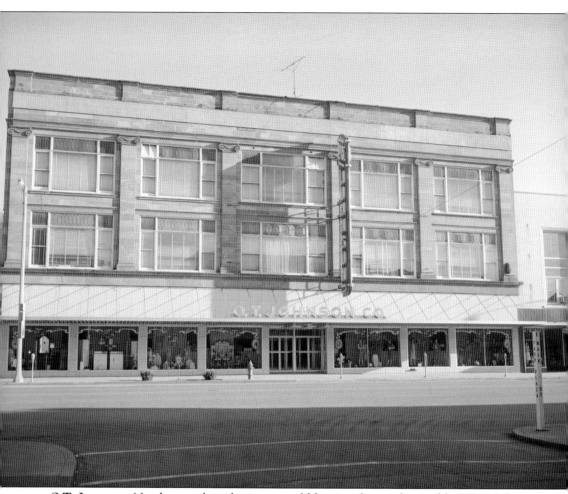

O.T. Johnson. No chapter about business would be complete without adding O.T. Johnson's Department Store. From the finest cosmetics, clothing for every member of the family, the famous luncheonette with its memorable doughnuts, a beauty salon, hats on the mezzanine, and the lady who ran the elevator, O.T.'s had it all and then some. Residents who were lucky enough to shop there still miss it.

Three
CHURCHES
THE LOST AND FOUND DEPARTMENT

BEECHER CHAPEL. This church was built in 1856 as the First Congregational Church when the Congregational and Presbyterian members of the first church split. It was at some point renamed Beecher Chapel, in honor of Edward Beecher, who was the minister at the church for many years. His sister was Harriett Beecher Stowe, who wrote *Uncle Tom's Cabin*. It was razed in 1966 for a parking lot.

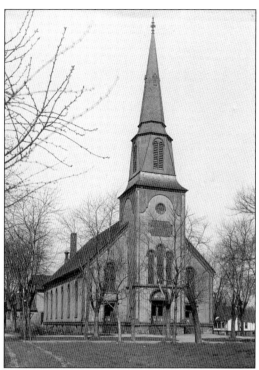

SWEDISH EVANGELICAL CHURCH. This church opened on August 24, 1851. The congregation had purchased the church shown, located on Seminary and Water Streets, from the Methodist Episcopal congregation. Sometime later the members changed the name to the First Swedish Church. (Courtesy Galesburg Public Library.)

FIRST UNITED METHODIST CHURCH. Dedicated on February 27, 1876, this church was the second one used by the congregation. It was destroyed by fire in July 1909, and a new church was begun in 1911 on Kellogg and Ferris Streets that still stands today.

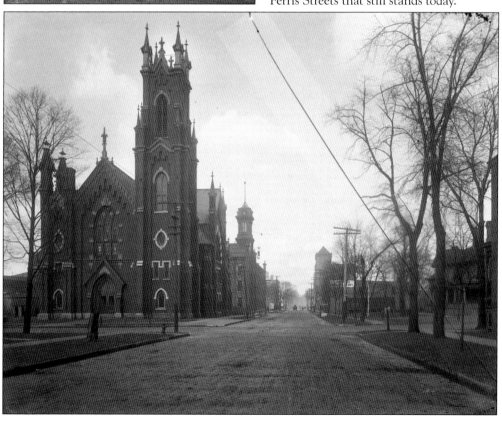

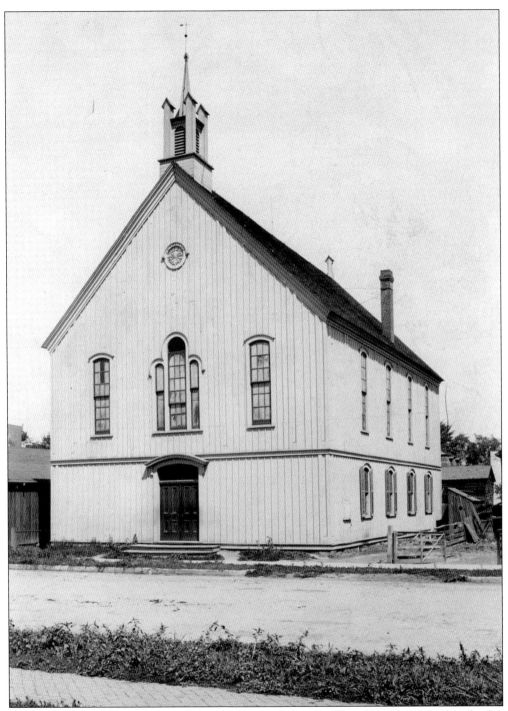

AFRICAN METHODIST EPISCOPAL CHURCH. Known today as Allen Chapel AME Church, this church was named after the first African American bishop of the AME denomination, Rev. Richard Allen. The members paid $400 for the first wooden church, located at 158 East Tompkins Street. It experienced two fires, but was rebuilt both times. It is one of the oldest original churches in Galesburg that is still active and at the same location.

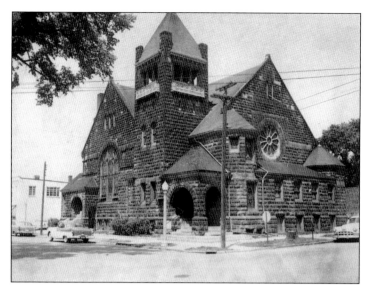

UNIVERSALIST CHURCH. This building was dedicated by Rev. George B. Stocking and was ready for worship on May 6, 1895. It was located on the northeast corner of East Tompkins and South Prairie Streets. But, in 1963, it was sold due to dwindling membership. The structure was razed for a parking lot.

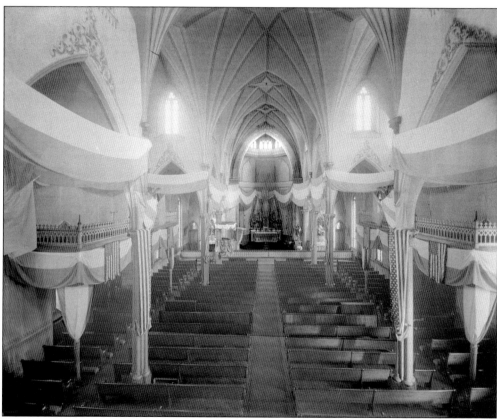

CORPUS CHRISTI CATHOLIC CHURCH. This 1898 image shows the church interior festooned with bunting and American flags. It is believed that this image was taken during the jubilee celebrations at the end of the Spanish American War. The church itself was built because of overcrowding at Saint Patrick's Church. Corpus Christi opened on October 4, 1885 and the Corpus Christi Lyceum School for Boys was built north of the church in 1887.

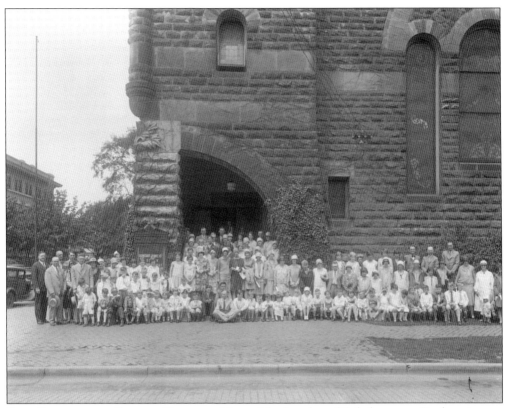

FIRST PRESBYTERIAN CHURCH, EXTERIOR. Many of the founders of Galesburg were Presbyterians; at one time, there were three Presbyterian churches. Later, two of them combined, and on December 4, 1893, this building at 101 North Prairie Street was dedicated and opened to take the place of the old church that had burned down.

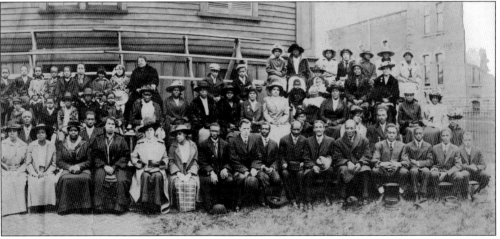

SECOND BAPTIST CHURCH CONGREGATION. This photograph shows members of the Second Baptist Church around 1910. Founded by a small group in 1864, by 1866 the congregation purchased a church building located on the southeast corner of Cherry and South Streets. Once of the first members was runaway slave Lewis C. Carter Sr., who was an active member and one of the first historians of Galesburg.

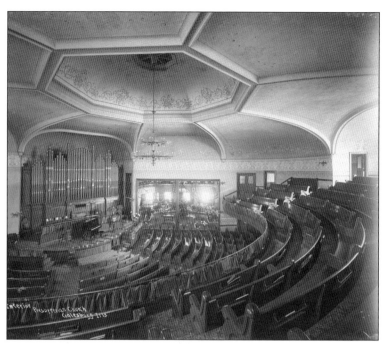

FIRST PRESBYTERIAN CHURCH, INTERIOR. The date of this photograph is not known, but there are electric lightbulbs in the chandelier. The view is from the balcony, and the image may have been taken at the same time as the exterior image for some sort of ceremony. The reception room at center is filled with different kinds of flowers.

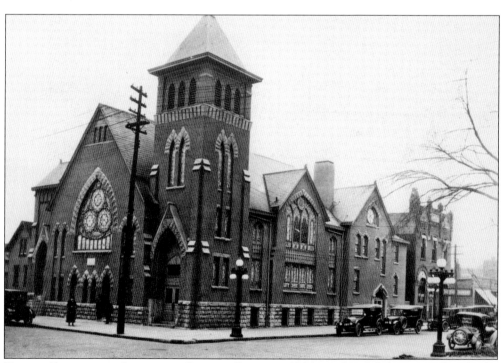

TRINITY EVANGELICAL LUTHERAN CHURCH. Begun in 1906 as a Swedish-language church, the congregation purchased the unfinished St. John's Church in 1907 on the southeast corner of North Kellogg and East Ferris Streets. The church officially opened in 1908 and is still in use by the congregation today.

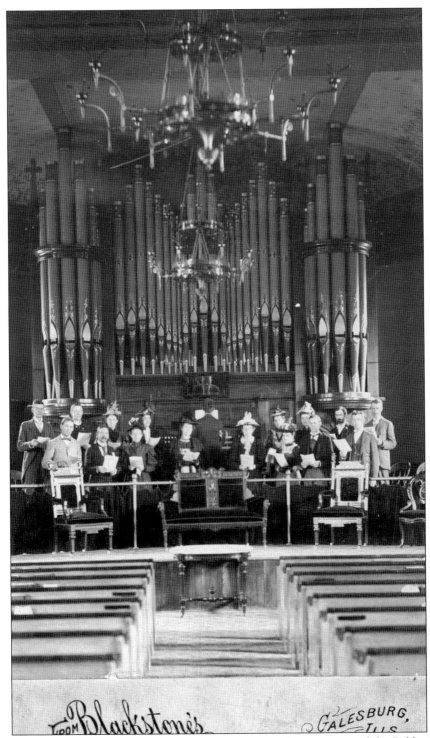

FIRST CHURCH OF CHRIST. This church, located on the southwest corner of the Public Square, was later known as the Old First Church. Here, the choir sings in front of the pipe organ in the late 1890s.

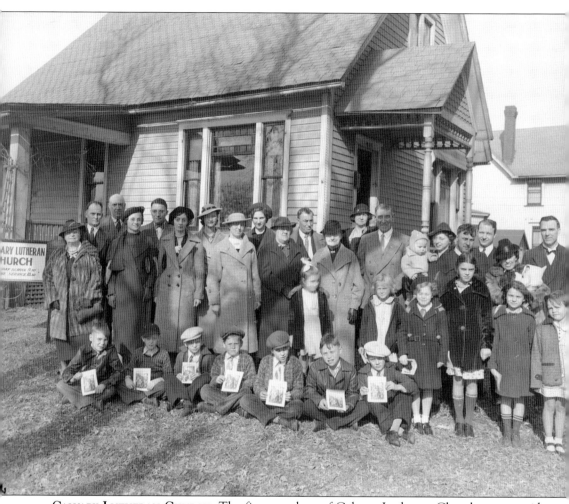

CALVARY LUTHERAN CHURCH. The first members of Calvary Lutheran Church pose outside of their house church at 676 South Lombard Street on November 17, 1937. The congregation continued to grow, and it received donations of an organ, altar, lectern, and other furnishings from other Missouri Synod Lutheran churches in and around Illinois. The church continues and is located on West Fremont Street.

Four

Government and Services
The City at Work

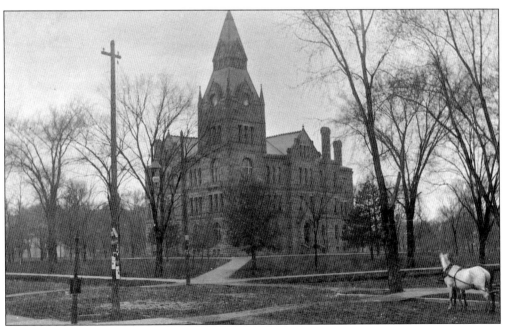

KNOX COUNTY COURTHOUSE. After a fierce battle in the courts, the county seat was moved from its original site in Knoxville to Galesburg, and a much larger stone building was constructed. This photograph was taken during the days when horses were still used for conveyance. Electricity was being used by the city, as evidenced by the streetlight hanging from wires.

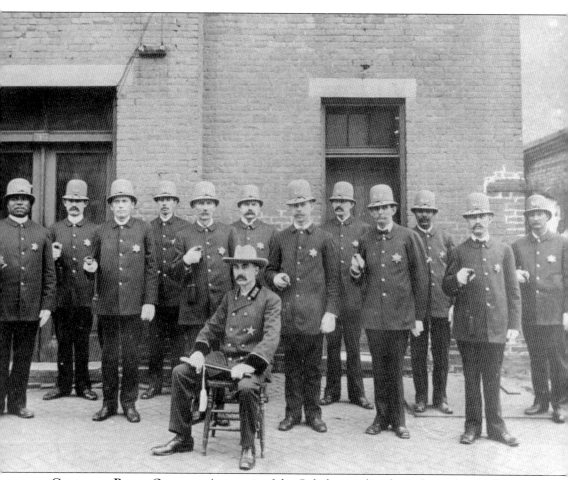

GALESBURG POLICE OFFICERS. A portrait of the Galesburg police force shows the chief sitting in front and his men behind him. This photograph was taken around 1899 judging from the cut of the uniforms and caps.

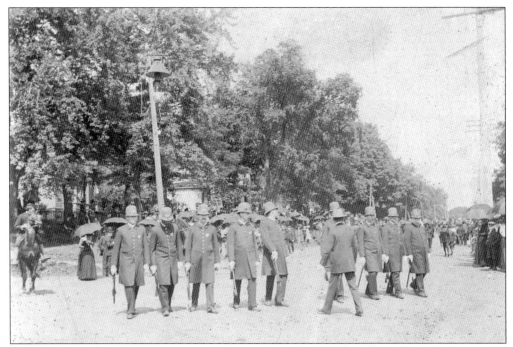

POLICE ON PARADE. These officers have either been marching in one of Galesburg's many parades or have been working crowd control, perhaps during the visit of Pres. William McKinley in October 1899 or by other dignitaries.

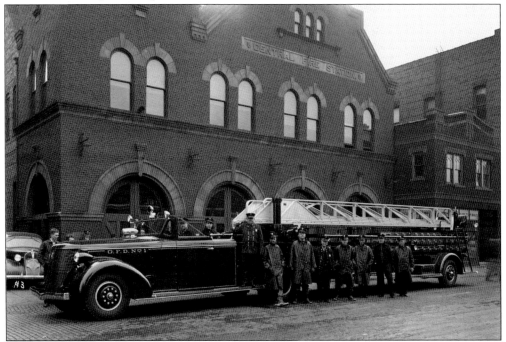

NEW FIRE TRUCK. These firemen have good reason to be smiling, as they may be standing in front of a new fire truck, Galesburg No. 1. Some of them are wearing waterproof gear. The photograph was probably taken in the late 1930s.

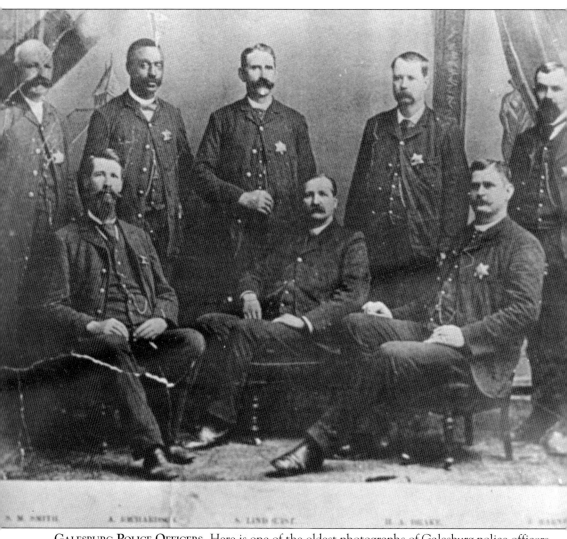

GALESBURG POLICE OFFICERS. Here is one of the oldest photographs of Galesburg police officers that the library owns. The names are not legible. The image dates to the early 1880s judging from the look of their jackets.

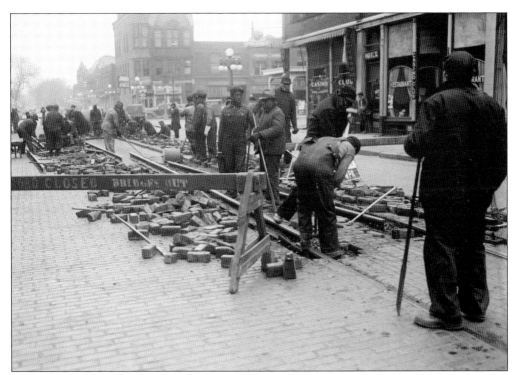

STREETCAR TRACKS REMOVED. In 1936, the Works Progress Administration began the removal of unused streetcar tracks in Galesburg. After years of slowly abandoning the track lines, Illinois Power & Light stopped the use of all electric trolleys in 1931 due to the increased use of automobiles.

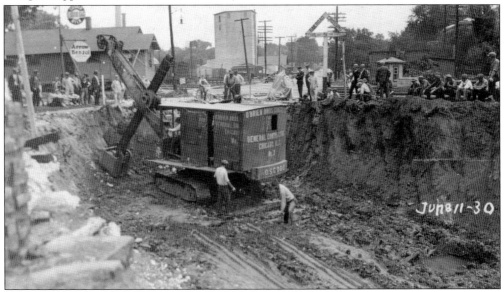

CONSTRUCTION AT CEDAR FORK. On June 11, 1930, a steam shovel removed great amounts of soil at Cedar Fork Creek just west of Hope Abbey on Main Street. The entire creek running through town was to be contained by tiles and concrete on each side and on the creek bed, intended to prevent flooding. Sewer pipes were being diverted to a water-treatment plant so the creek would carry only storm water through town.

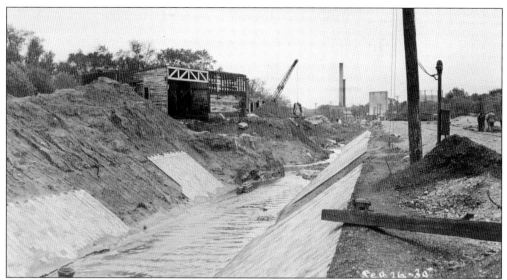

CEDAR FORK CREEK. Here, Cedar Fork Creek construction is under way. Tiles were laid and then covered with concrete. Bridges were built over the creek, and storm drains would carry only rainwater to the creek. For decades, the creek was a source of a foul smell. Once completed, Galesburg residents could take a deep breath and not worry about the odor when the wind blew their way.

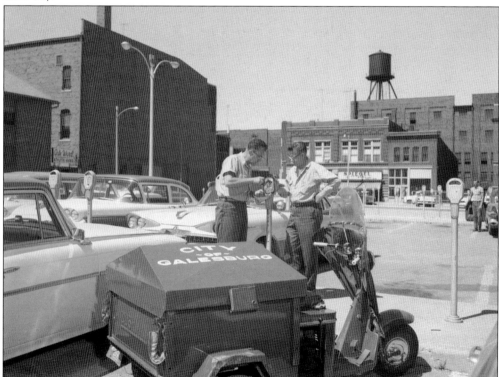

FIXING A PARKING METER. Two city employees are working on one of the meters, ensuring that its gears and cogs operate properly. This location is what most people remember as the parking lot behind W.T. Grants, but part of the space is now Jimmy Johns.

Five

COLLEGES

THE KEY TO THE GOLDEN DOOR

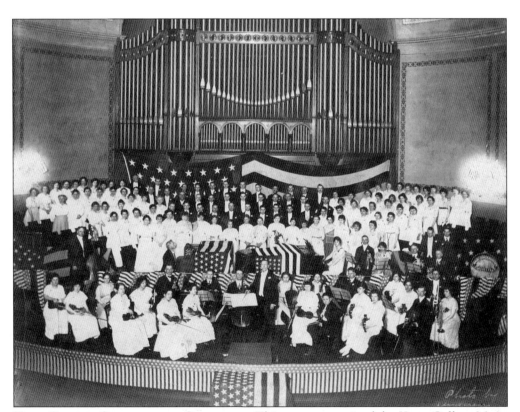

KNOX COLLEGE CONSERVATORY ORCHESTRA. This group portrait of the Knox College Music Conservatory Orchestra was taken in the Central Congregational Church early in the 20th century. The exact date is unknown, but this may be part of the celebration of the end of World War I. (Courtesy of F.E. Augerson.)

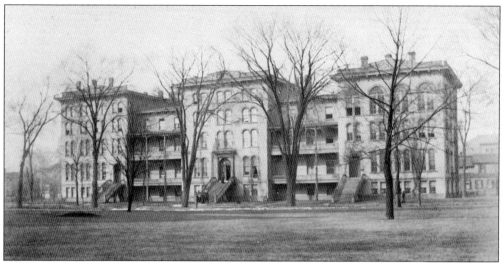

WHITING HALL, KNOX FEMALE SEMINARY. Women began taking classes at the Knox Female Seminary in 1841, but it was not until 1856 that enough money was available to create housing for women. Constructed in stages, the building was called Whiting Hall. By 1870, coeducation became a reality at Knox College. Now privately owned as an apartment building, some of the building's windows still have the Knox College insignia on them.

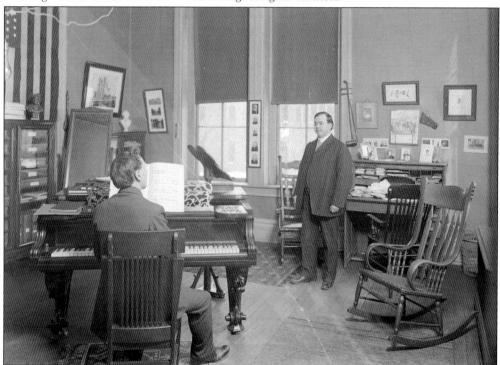

WILLIAM F. BENTLEY. Serving as the director of the Knox Conservatory of Music from 1885 until 1936, Bentley (right) conducted the choir and taught piano, organ, violin, theory of music, sight reading, and solo singing. The conservatory blossomed under his tutelage, and his students formed the Knox Military Band and Knox College Choir. From ticket sales, they earned enough money to purchase pianos for the college and the pipe organ for Beecher Chapel.

KNOX CONSERVATORY OF MUSIC. This large house was the location of the offices and rehearsal rooms for the Knox Conservatory of Music. The house was deeded to the college, and offices and rehearsal rooms that had been in Whiting Hall were moved there. The small building right of center was for many years the King Cole Book Store. At the far right is Beecher Chapel.

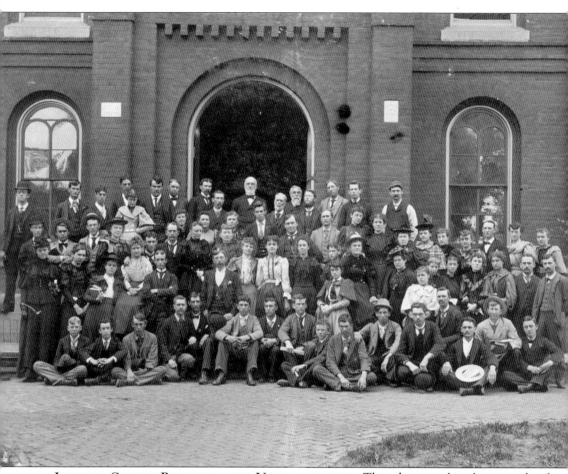

LOMBARD COLLEGE PROFESSORS AND UNDERGRADUATES. This photograph, taken outside of Lombard College's Old Main building, dates to around 1895, when Prof. John Van Ness Standish was president of the college. He is shown in the last row, at center. Other professors present are J.C. Lee, L.A. Parker, Jon W. Grubb, and F.W. Rich.

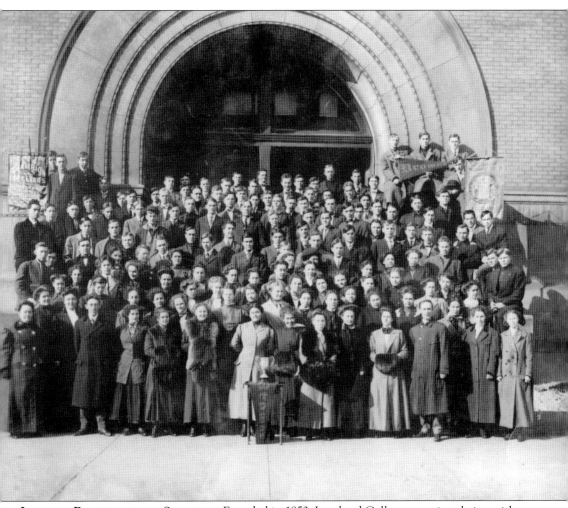

LOMBARD PROFESSORS AND STUDENTS. Founded in 1853, Lombard College came into being with a gift from Benjamin Lombard, an Illinois farmer and businessman. It was coeducational from the beginning, and this photograph shows both male and female students. In the back row, center, is John Van Ness Standish, professor and president of the college. From the style of the women's clothing, this photograph was probably taken in 1895.

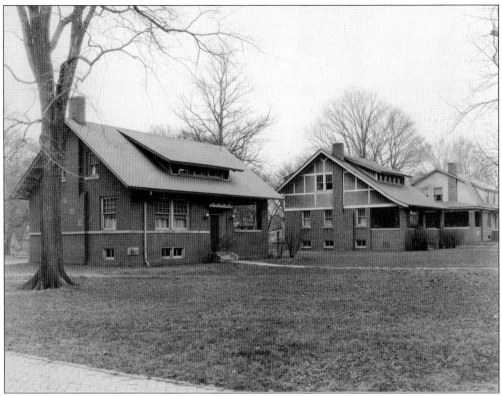

LOMBARD COLLEGE SORORITY ROW. These bungalow-style houses are believed to have been built in the early years of the 20th century. The sorority houses are Delta Zeta (left), Alpha Xi (center), and Pi Beta Phi. The photograph was probably taken in the 1920s.

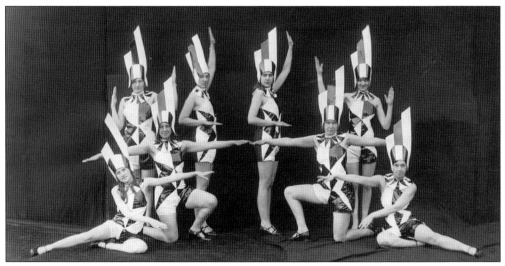

LOMBARD STEPPERS. Beginning in 1925, the Lombard Steppers dance troupe began learning from director Margaret Stookey and her assistant Helen Larson, another student and a Galesburg dancer of some renown in the area. Their costumes may look strange, but during the Roaring Twenties they were probably "the cat's meow." The troupe continued until the college closed in 1931.

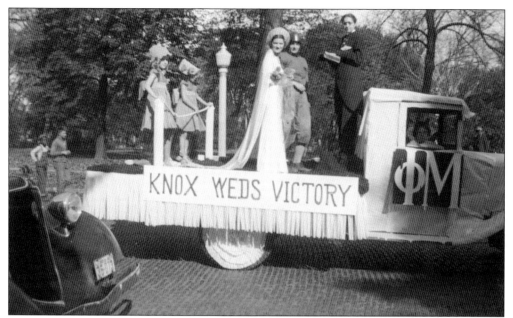

KNOX COLLEGE HOMECOMING PARADE. Members of the Knox College chapter of the Phi Mu fraternity pose with their float, "Knox Weds Victory." It shows a bride "marrying" a Knox football player, with a very young-looking minister doing the honors. The photograph was probably taken in the 1930s.

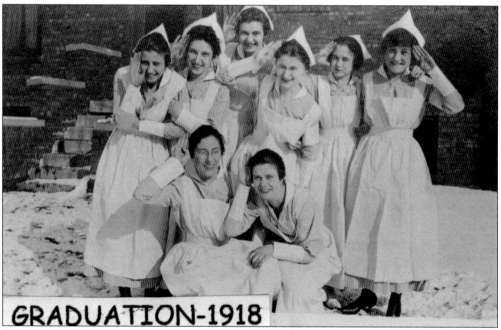

SCHOOL OF NURSING, CLASS OF 1918. Giving the photographer a salute on a cold winter's day, a group of six student nurses attending Galesburg Cottage Hospital School of Nursing is having a great time in between classes and nursing duties. Student nurses took a full course of classes and worked many hours on the hospital floors, including night shifts. There were strict rules of behavior in and out of school.

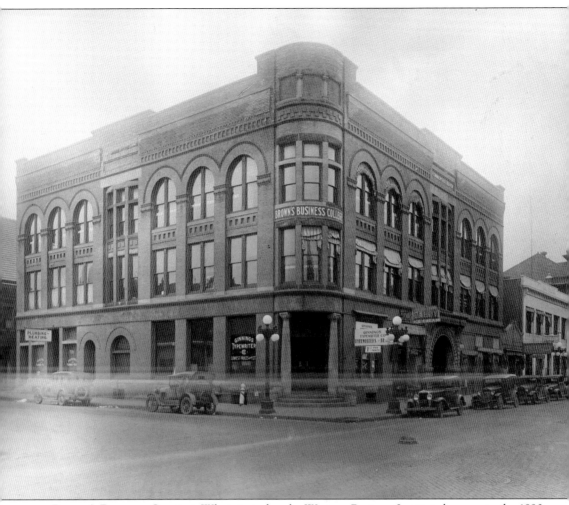

BROWN'S BUSINESS COLLEGE. What started as the Western Business Institute became in the 1890s Brown's Business College. Located at 119 South Cherry Street in the Commercial Block Building, the school taught bookkeeping, shorthand, typing, and other skills needed to work in an office setting. The school remained open until 1967, when Carl Sandburg Junior College took over the space and began teaching these courses. It now houses apartments and businesses.

Six

INDUSTRY

A Better Mousetrap

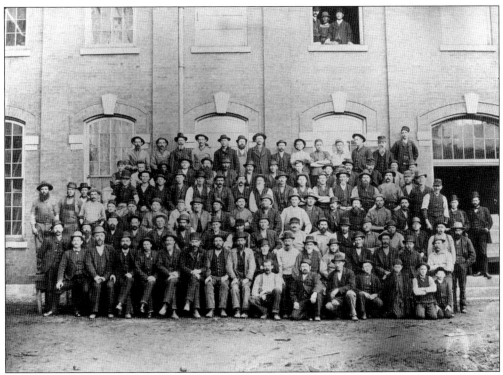

BROWN CORN PLANTER WORKS. In 1848, farmer and inventor George W. Brown envisioned a new way to plant corn and constructed a prototype machine that worked well. By 1878, he had built a factory in Galesburg on South Kellogg Street and had 230 employees. They could produce up to 8,000 machines per year. This photograph shows approximately 110 employees, two of whom may be child laborers.

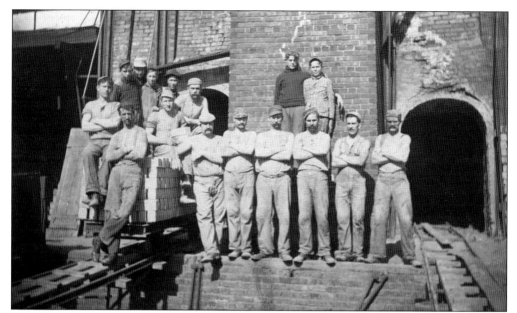

PURINGTON COMPANY EMPLOYEES. Brickyard employees take a break for the photographer. Located in East Galesburg, this facility opened in 1890. The clay came from nearby shale pits, and 13 kilns were firing day and night. The bricks paved 60 miles of Galesburg streets and other towns' streets, and millions were used in the construction of the Panama Canal. The plant employed 500 to 800 men; it closed in 1974.

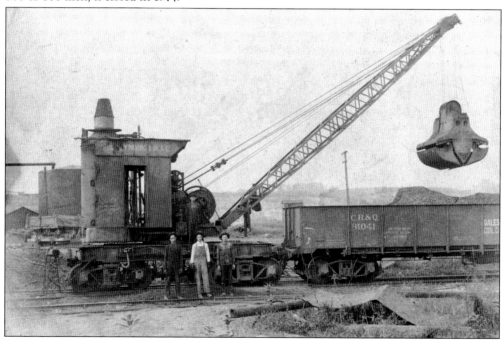

PURINGTON STEAM SHOVEL. This early steam shovel and four employees of the Purington Paving Brick Company are loading or unloading material from a Chicago, Burlington & Quincy Railroad gondola car. One of the men is standing on the steam shovel above the other three. The photograph, taken in East Galesburg, is from around 1900.

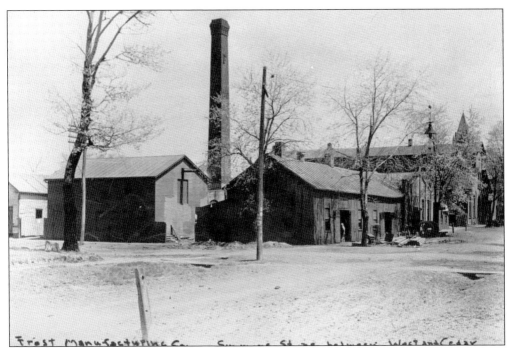

FROST MANUFACTURING. The exterior of Frost Manufacturing, located between West Simmons and South Cedar Streets, is seen here sometime after 1900. A larger factory building made of brick is on the far right, and the smokestack in the center has the letter "F" on it. The small peak on the far right is the steeple of the Central Congregational Church.

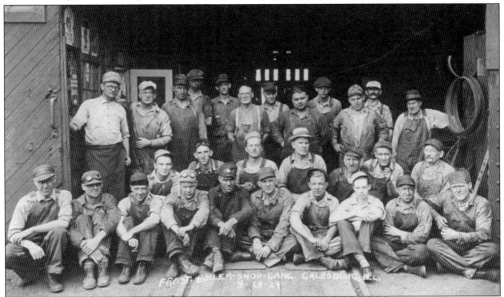

FROST EMPLOYEES. Known mainly for its boilers for locomotive engines, the Frost Manufacturing Company was located at 121 West Simmons Street in 1904. J.P. Frost began the business in 1851 and eventually had 60 employees. In one year, it turned out 50 steam engines, 44 boilers, 44 clay crushers, and 100 complete elevators. The factory stood at what is now the location of the Mary Allen West Tower.

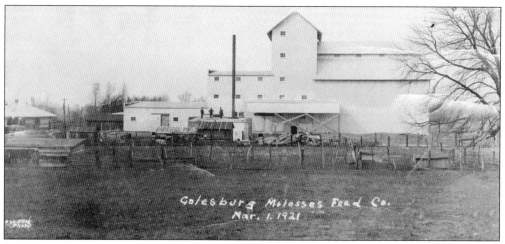

GALESBURG MOLASSES & FEED COMPANY. Producing feed for livestock and poultry, this company decided to add molasses, making it sweet, so that livestock would eat more, have better digestion, and absorb more nutrition. Located at 1021 South Henderson Street, the factory was in operation from 1920 to 1931.

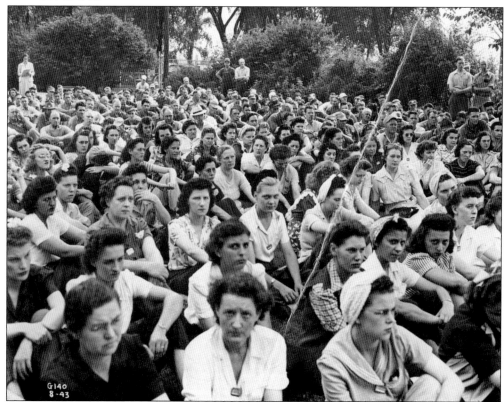

MIDWEST MANUFACTURING EMPLOYEE MEETING. Seen in August 1943, these "Rosie the Riveters" look as if they have already put in a full day's work. During World War II, the company switched from making consumer goods to producing K-ration cans, mines, and Navy floats for seaplanes. The women and some older men on the home front in Galesburg were doing their part for the war effort.

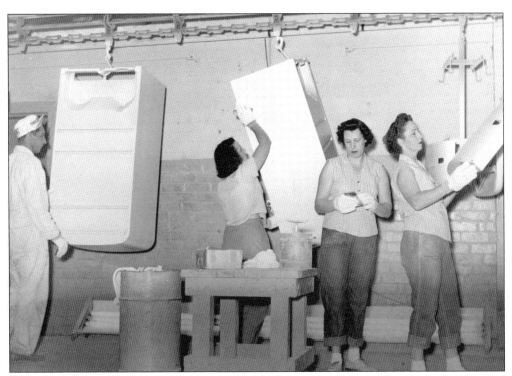

ADMIRAL CORPORATION SANDING LINE. One of the largest employers in the area opened in 1904 as Coulter Disc and continued to grow and change hands several times, eventually becoming commonly known as Admiral's. It provided jobs for tens of thousands people in the Galesburg area for approximately 100 years. Shown here are, from left to right, John Carter, Harriett Bland, Florence Levene, and Marietta Vilardo. The plant produced quality refrigerators and freezers that were sold worldwide.

ADMIRAL ASSEMBLY LINE. In the 1950s, a woman uses a pneumatic screwdriver to place and tighten screws on the freezer doors of refrigerators made at Midwest Manufacturing. The company was better known by locals as Admiral's. It is interesting to consider just how many unit doors this woman worked on during her tenure on the assembly line. (Courtesy of William Gliessman.)

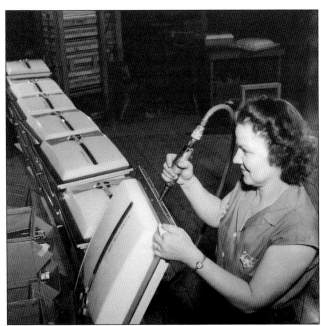

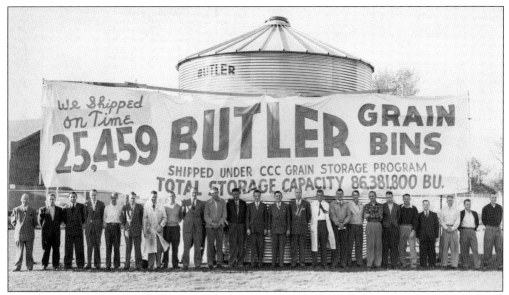

BUTLER'S GRAIN BIN PROJECT. It is hard to imagine that bumper crops of grain would be a problem, but in the late 1940s the concern was lack of storage. Big yields filled grain elevators to the top. So, the US government guaranteed loans to farmers to purchase and place steel grain bins on their farms. Butler Manufacturing produced 25,569 of these bins. Here, some employees stand in front of one of the company's bins. (Courtesy of William Gliessman.)

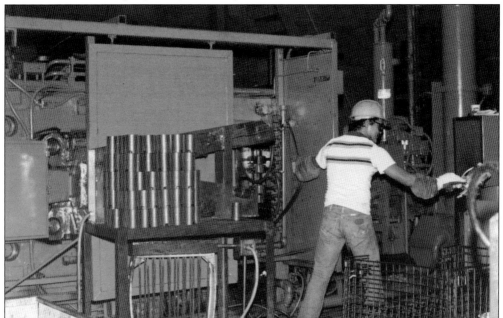

GALE OUTBOARD MARINE FACTORY. An employee of Gale Products appears to be working with an extruder machine around 1970. While working with these large, powerful, hot machines, employees wore gloves to keep their hands from burning on the newly molded plastic parts. At its peak, the plant had about 1,000 employees making good wages. When the plant closed in the early 1980s, it was a blow to Galesburg and a harbinger of things to come. (Courtesy of William Gliessman.)

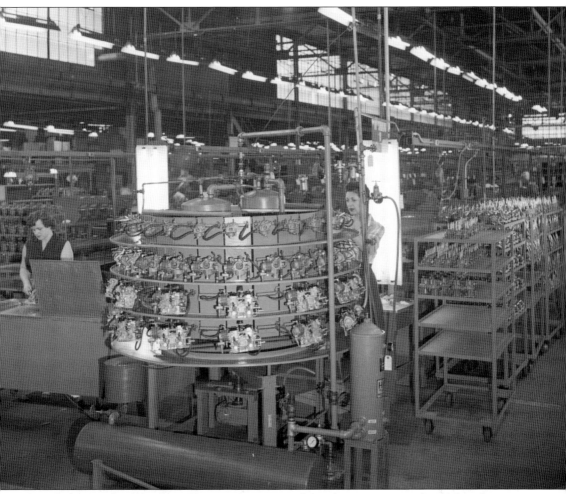

GALE PRODUCTS ASSEMBLY LINE. Two women appear to be working on parts used in outboard motors in April 1961. The motors made Gale's outboard marine engines famous. Working in a factory was hard, and conditions were made more difficult with the heat and humidity of the summer months. But the workers were compensated with good wages. (Courtesy of William Gliessman.)

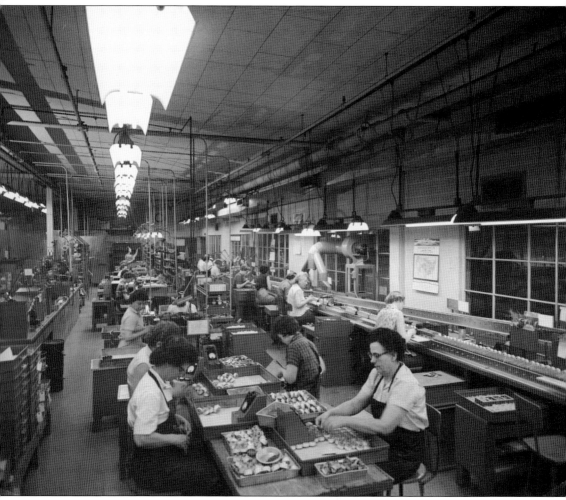

GALE PRODUCTS TABLE WORK. In April 1961, female employees of Gale Products perform what was called table work. It took some seniority to get a job in which one sat, preferable to jobs in which one stood all day at an assembly line. Galesburg factories showed no discrimination between the sexes, with women hired to work alongside men. (Courtesy of William Gliessman.)

Seven
RAILROADS
LINKS TO VAST SPACES

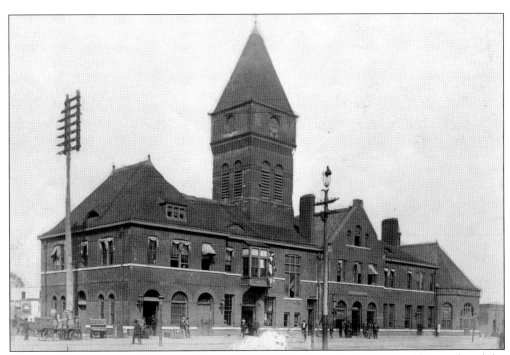

CHICAGO, BURLINGTON & QUINCY DEPOT. In 1885, this imposing CB&Q building replaced the first wooden railroad depot. As well as a waiting room, it held railroad offices and a restaurant. The size of this building reflects the number of citizens in Galesburg, many of whom worked for the CB&Q. It was destroyed by fire on May 27, 1911.

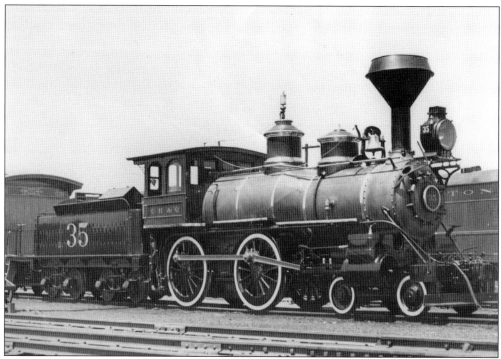

CB&Q LOCOMOTIVE NO. 35, C. 1934. This locomotive and its coal tender sit in the rail yards waiting to make a trip to the Century of Progress Expo in Chicago. The romance of rail travel is brought to mind when seeing these older, decorative vehicles that had power of monstrous proportions. Their low, deep whistle carried on the wind brought to mind home, prosperity, and friendlier times on the "Q." (Courtesy of Bob Kimmit.)

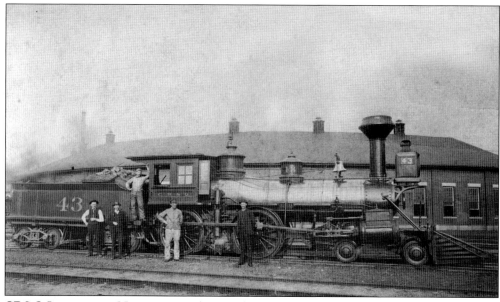

CB&Q LOCOMOTIVE NO. 43. Here, four employees of the CB&Q Railroad stand in front of a locomotive and coal tender. Behind them is an early roundhouse known as the Little Roundhouse. It is believed that this photograph was taken in the 1880s.

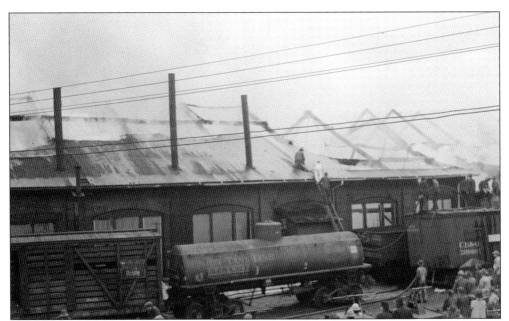

CHICAGO, BURLINGTON & QUINCY FIRE. A fire is consuming one of the railroad's workshops. Employees on top of a railcar, on a ladder, and on the roof are all struggling with a water hose. It appears to be a lost cause, as the left part of the building is smoking badly. A tank car and an empty cattle car are shown on the left.

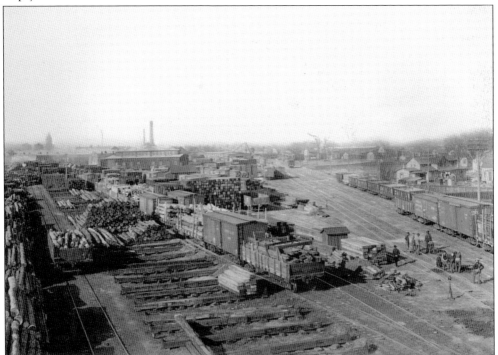

WOOD CAR SHOPS, 1930s. This photograph looking north toward the blacksmith shops shows the wood car shop area in the CB&Q rail yards. Freight cars were built and repaired at that location. The area was located near Third Street, close to the childhood home of Carl Sandburg.

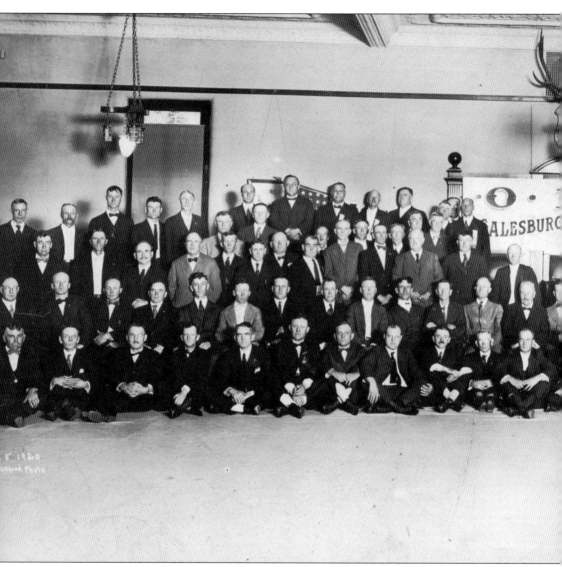

ORDER OF RAILROAD CONDUCTORS. This image of the Galesburg Division No. 83 shows men in their Sunday best posing for a group portrait in the Elks Hall on August 5, 1920. The original group, organized around 1868, was a fraternal and temperance society. It became a labor union

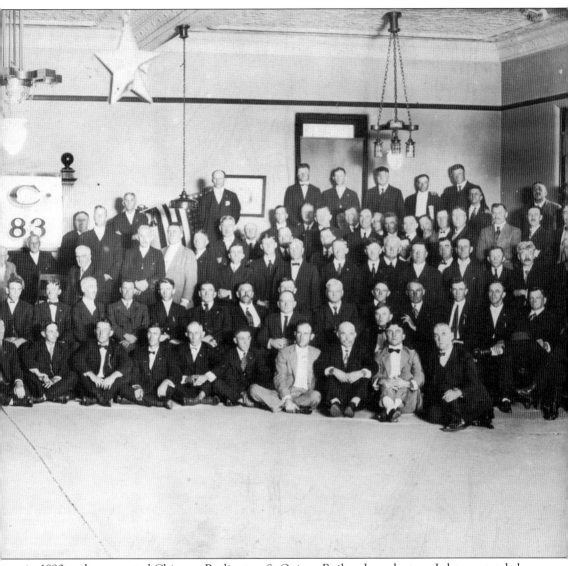
in 1890 and represented Chicago, Burlington & Quincy Railroad conductors. It later extended membership to brakemen. (Courtesy of Charles Osgood.)

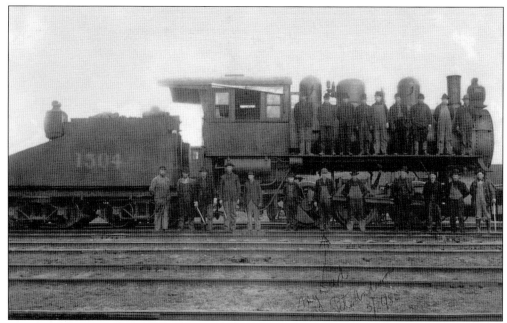

LOCOMOTIVE NO. 1504, C. 1915. Chicago, Burlington & Quincy Railroad employees stand on and around locomotive No. 1504. Besides yard workers, this image probably also shows the engineer, switch foreman, fireman, and switchman. The sixth man from the right, standing on the ground, is identified as Pete Anderson. He is indicated with the date "5/26/1884," which may have been his birth date.

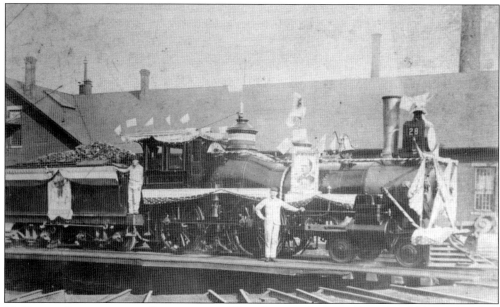

MCKINLEY SPECIAL AT THE ROUNDHOUSE. This photograph shows the special locomotive that pulled the train that Pres. William McKinley, his wife Ida, and his cabinet members used to get to Galesburg on October 7, 1899. McKinley was here during the anniversary of the Lincoln-Douglas debate that took place at Knox College. He also held a cabinet meeting at the home of Clark E. Carr, the first such meeting held outside of Washington, DC.

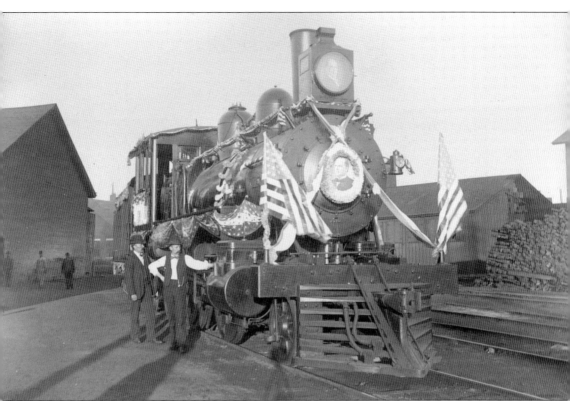

McKinley Glorifies the Railroad Locomotive. Nothing could be more ostentatious than to have your portrait plastered on the front of a locomotive surrounded with paper flowers, bunting, and American flags. But, that was how they did it in the Victorian era. Little did William McKinley know that in about two years he would be assassinated. Vice President Theodore Roosevelt would take his place as president of the United States.

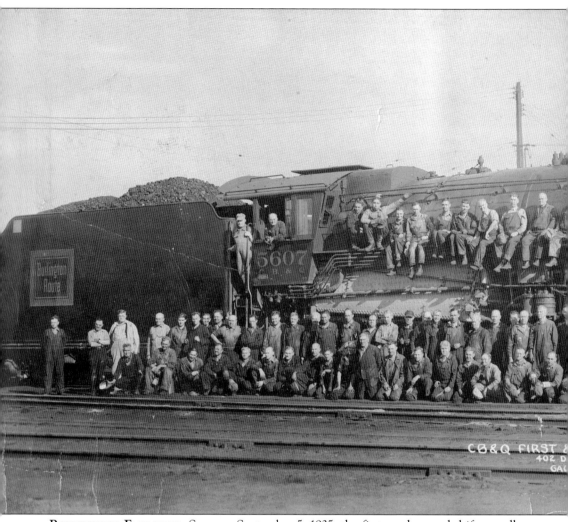

ROUNDHOUSE EMPLOYEES. Seen on September 5, 1935, the first- and second-shift roundhouse employees sit on and stand in front of locomotive No. 5607. They are quite proud that they have

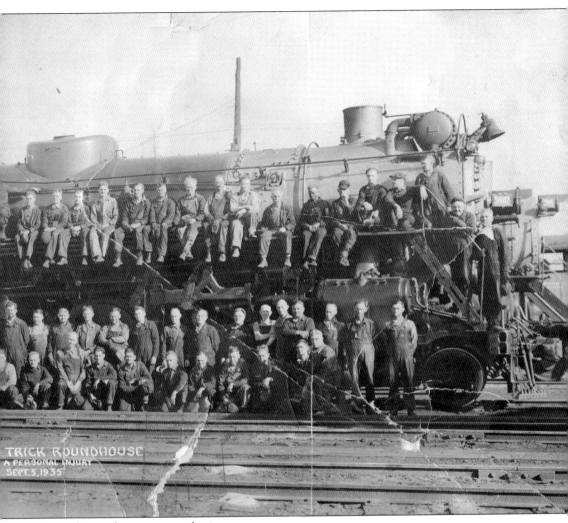

gone 402 days without a personal injury.

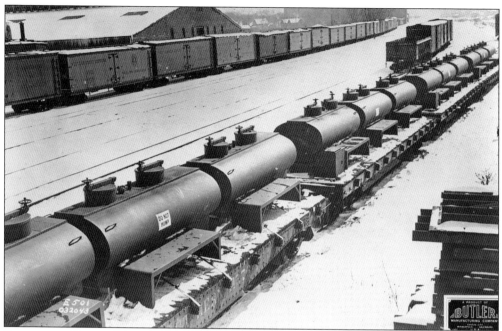

RAILCARS AT BUTLER MANUFACTURING. During World War II, freight and tanker cars sit next to one of the Butler Manufacturing buildings. The tankers have a sign on them, "Do Not Hump," which meant not to send them down the humps to couple them to other cars. They most likely contain toxic, flammable fluid. This photograph was taken on March, 20, 1943.

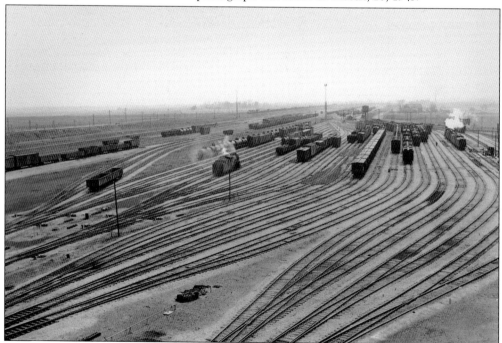

CHICAGO, BURLINGTON & QUINCY YARDS. Like pieces of an elaborate puzzle, railcars holding goods from all over the world are being moved around by steam locomotives. Employees are also in the yards working around this mighty maze of rails. This photograph probably dates to the 1950s.

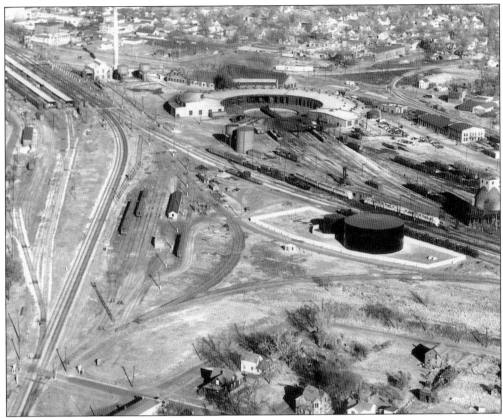

CB&Q ROUNDHOUSE. Now long gone, the CB&Q Railroad roundhouse is still vivid in the memories of many who worked for the railroad. There are not only the visual memories, but sounds and smells as well. In 1930, the roundhouse had 41 stalls, but by 1970 it had only half the capacity, with 16 stalls. Like many of the old buildings in the yards, it is now gone.

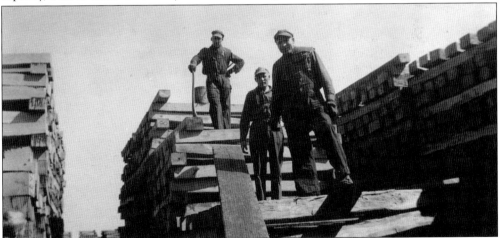

TIE-PRESERVING PLANT EMPLOYEES. This 1930s photograph shows Burlington Tie Plant employees Clyde Sterr (left), Vic Olson (center), and an unidentified person. They are working with railroad ties from a storage area at the plant to send them to be preserved in creosote. The tie plant was located southwest of Galesburg.

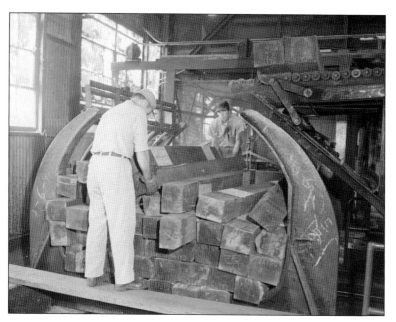

BURLINGTON TIE PLANT MACHINERY. Two employees are working with newly cut railroad ties that are coming off a conveyer belt. The ties would be wired together and placed on a flat railroad car and then stacked in the plant's yard for curing.

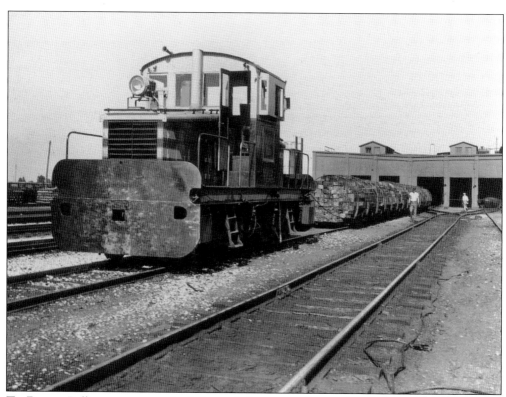

TIE PLANT. Pulling many tons of rail ties took the power of a switch engine, which took them to the plant yard to be stacked and cured before the ties were pressure-treated with creosote at the Burlington Tie Plant. When people drove by the plant on Route 41, the odor of the creosote and the noise of the engines made quite an impression.

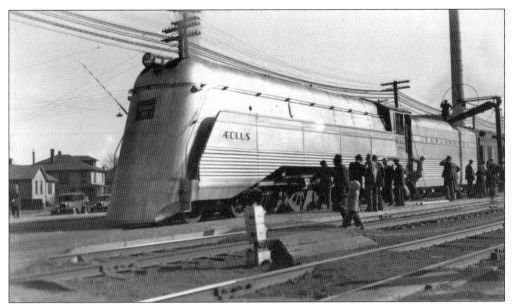

AEOLUS LOCOMOTIVE. In 1937, the CB&Q attached to locomotive No. 4000 a stainless steel shroud to give it a streamlined and more modern look, which was all the rage in the 1930s. It was given the nickname *Big Alice the Goon*. The shroud was removed at the start of World War II and could not be maintained due to war restrictions.

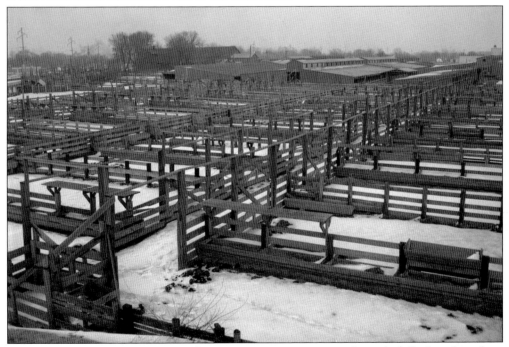

CB&Q RAILROAD STOCKYARDS. What was once a noisy series of corrals full of cattle, calves, and hogs is now just an empty lot at 538 Louisville Road. In years past, western Herefords, Angus steers, and hogs arrived regularly to be auctioned off to farmers and meatpackers. Radio station WGIL gave three daily reports on the latest prices and stock summaries live from the stockyards. This photograph was taken in the 1950s.

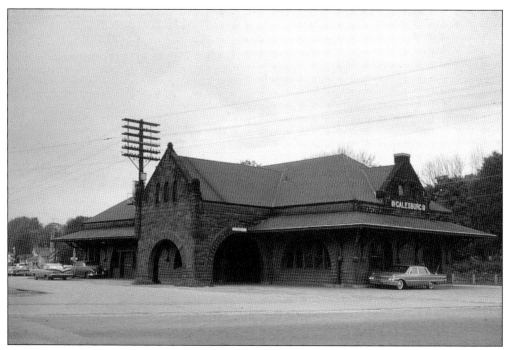

ATCHISON, TOPEKA & SANTA FE STATION. After much haggling to ensure that the railroad would come through Galesburg, this stone depot was opened on February 2, 1889. Besides comfortable seating, the depot boasted a marble lunch counter, a fireplace, and steam heat. In 1964, the railroad, with civic and city leaders' approval, was razed. In its place was built a pre-engineered steel-and-glass building to "beautify the area" in the early 1960s.

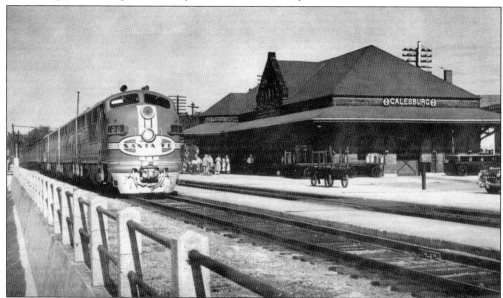

AT&SF LOCOMOTIVE. Seeing this locomotive from the 1950s reminds one of the *Super Chief*, which ran between Chicago and Los Angeles from the 1930s through the 1960s. These cars were rich with amenities. The trains even had private dining rooms for parties and corporate dinners. It makes one wonder how many movie stars were on these trains when they stopped in Galesburg.

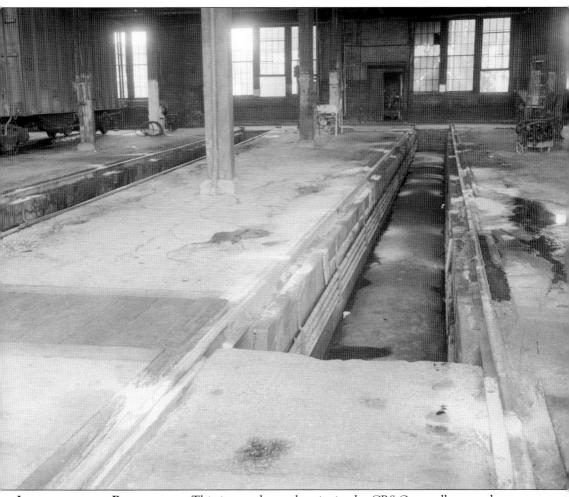

INTERIOR OF THE ROUNDHOUSE. This image shows the pits in the CB&Q roundhouse, where men would get under the locomotives to inspect and repair them. Also shown are pieces of machinery that were probably used every day. A freight car to the left needs some kind of repair. The photograph was probably taken in the 1960s.

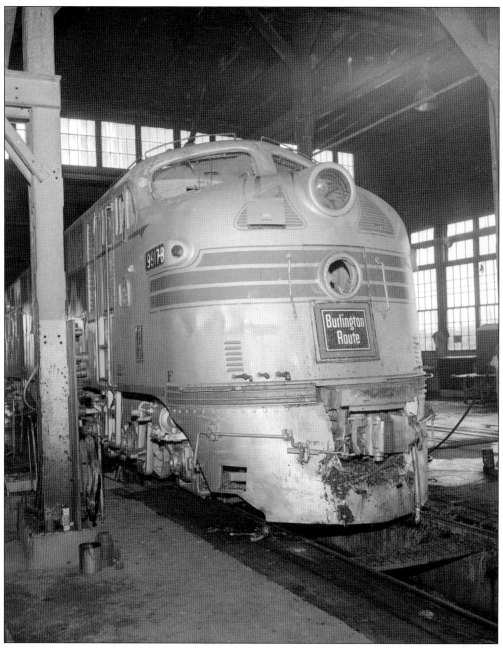

LOCOMOTIVE IN THE ROUNDHOUSE, 1950S. Gleaming metal and a streamline design were the marks of Burlington Route trains. This locomotive is in the roundhouse in Galesburg for some repairs. It comes from a time when Vistadome windows, private berths, and linen table cloths in the dining car were on most trains.

Eight
SCHOOLS
AN INVESTMENT IN KNOWLEDGE

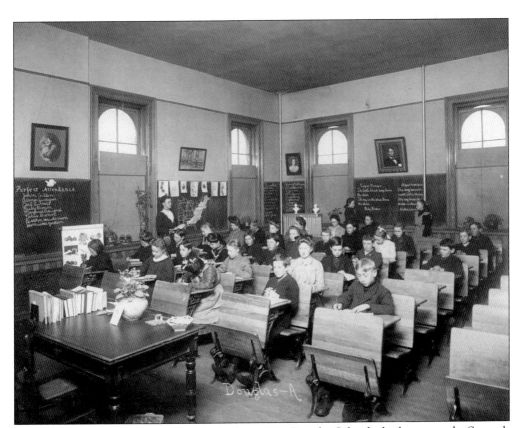

DOUGLAS SCHOOL CLASSROOM. Built in the late 1860s, Douglas School, also known as the Seventh Ward School, was located at the corner 1005 South Seminary Street at Fourth Street. It appears that the 30 students in this classroom are learning grammar.

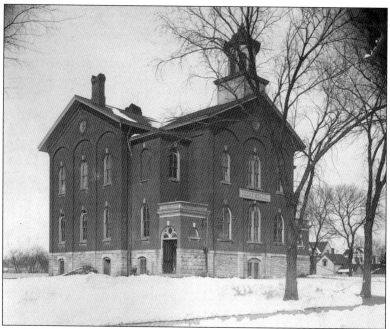

COOKE SCHOOL. Located on the northeast corner of Academy and Knox Streets, this brick-and-stone building opened in September 1893. It contained four schoolrooms and was a replacement for the original Fifth Ward School. It was named in honor of Milo D. Cooke, who was the principal of the Fifth Ward School for several years.

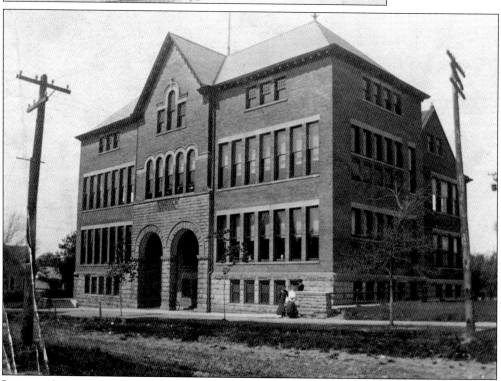

LINCOLN SCHOOL. Completed and ready for occupancy in January 1890, an imposing, three-story school was built to relieve overcrowding in the Fourth and Fifth Ward Schools on the east side of Galesburg. It was located at East North and North Pearl Streets. At its opening, the school board director, George A. Murdoch, presented an American flag to the school to be flown on holidays and special occasions.

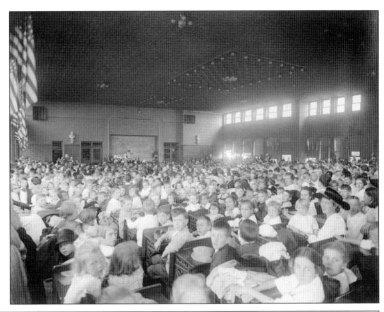

HIGH SCHOOL STUDY ROOM. This room was used twice a day for assemblies of the student body. But, on this day, it was being used as an auditorium for primary schools. There is a stage at the far end of the room, and children are supposed to be watching a program; most, however, are watching the photographer. The image was probably taken around 1900.

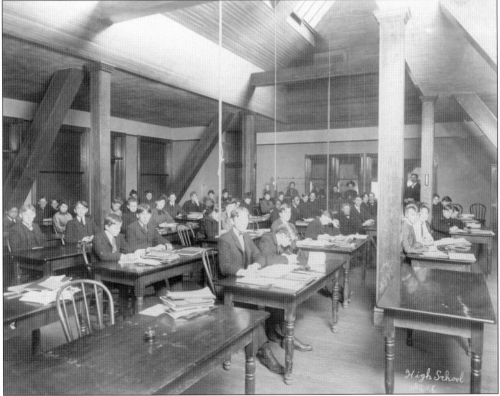

ATTIC CLASSROOM. In 1903, the second Galesburg high school, located on the northwest corner of Tompkins and South Broad Streets, became so overcrowded that three rooms in the attic were remodeled to use as classrooms. Opening skylights were constructed to let in light and to help remove some of the excessive heat from the third floor. The high school burned to the ground in 1904. (Courtesy of Galesburg School District 205.)

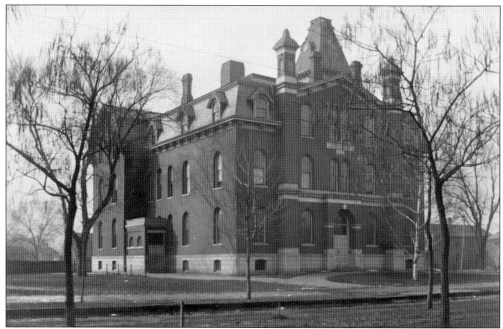

CHURCHILL SCHOOL. Built in 1865, this school was originally called Central School because of its location, but it was eventually changed to Churchill School. It had 10 rooms with 63 desks in each, two recitation rooms, and a chapel occupying the east half of the third floor. It burned down in 1965, along with the second Galesburg High School.

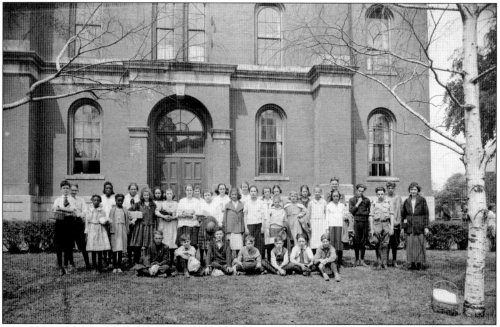

FIRST CHURCHILL SCHOOL AND STUDENTS. Students of Churchill School, located on the southwest corner of South Broad and West Simmons Streets, pause for the camera before heading to a picnic. From the clothes they are wearing, it looks like it is a warm spring day. The style of their clothing hints that the photograph was taken around 1900.

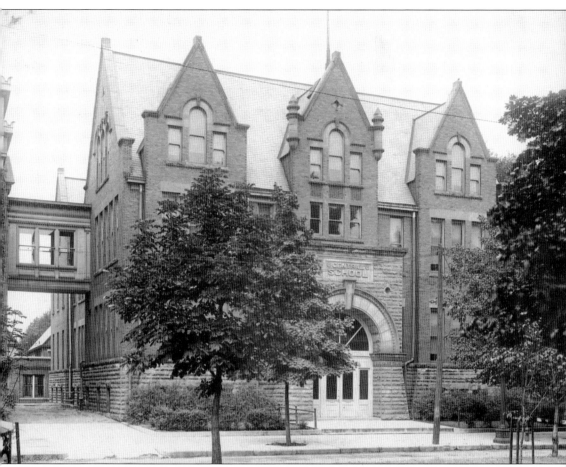

CENTRAL PRIMARY SCHOOL. Located between Galesburg High School on the south and Churchill School on the north, Central Primary School was completed in 1904. Its students previously met in churches or old houses, except for a few years when they met on the first floor of Galesburg High School. Note the enclosed walkway on the second floor connecting the building to the new high school.

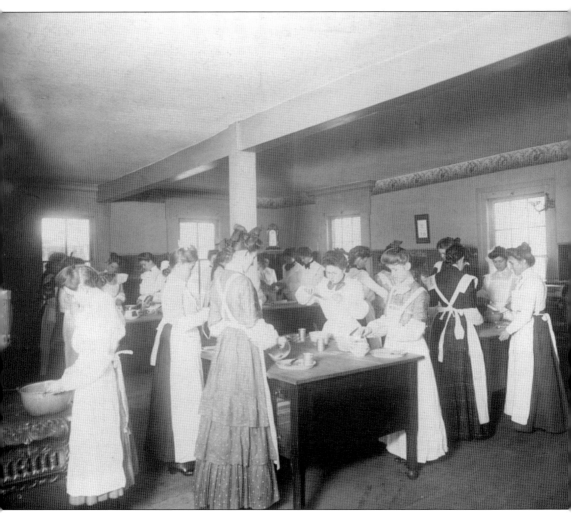

CAN SHE BAKE A CHERRY PIE? Probably, but these girls would learn much more, including the basics of using and supplying a kitchen, using a stove, laying the table, making soups and baked goods, canning and preserving, choosing meat, and, lastly, making a four-course lunch. The second high school burned to the ground in the spring of 1904, but not from a hot stove. (Courtesy of Galesburg School District 205.)

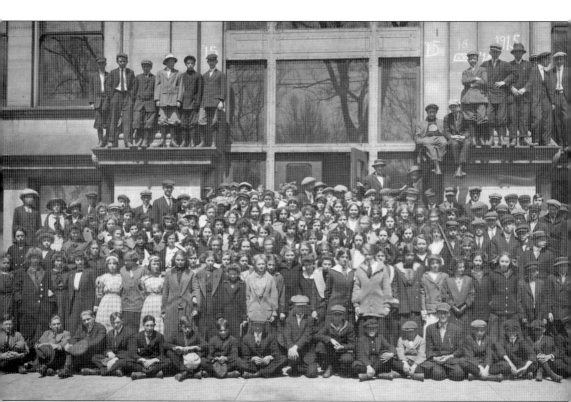

HIGH SCHOOL CLASS OF 1915. Students of the class of 1915 stand in front of the second Galesburg High School on the southwest corner of Tompkins and Broad Streets. They were there with their whole lives ahead of them, not realizing that two world wars, the Roaring Twenties, and the Great Depression lay before them. Most of them would survive, and their children would be called be the "greatest generation."

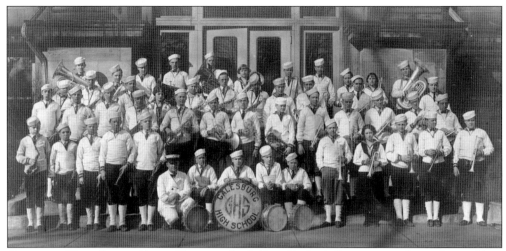

GALESBURG HIGH SCHOOL BAND. Playing at football and basketball games, parades, and assemblies, as well as at fraternal clubs and Lombard College games, the Galesburg High School band was a source of pride for the school and included four brave girls. They are all seen here in 1924, wearing sailor suits and spats. It is recorded that "the band met their zenith when it presented a program at the Armory."

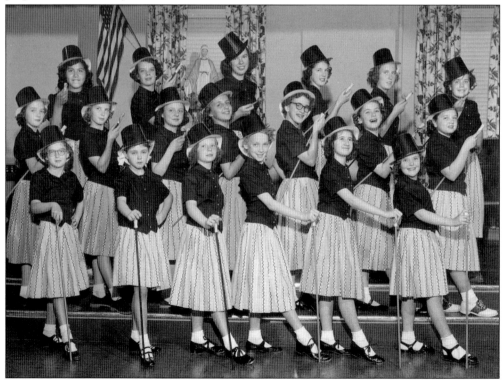

ST. JOSEPH SCHOOL DANCING CLASS. These happy girls with tops hats and canes are part of Mrs. Howard's tap-dancing class at St. Joseph grade school in 1958. The girls appear to be enjoying themselves. The dance classes were held in the school auditorium, located between the school and the convent, where the teaching nuns, the Sisters of Providence, lived. (Courtesy of Costa Catholic Academy.)

Nine
RECREATION AND CULTURE
WHY WE LOVE THE BURG

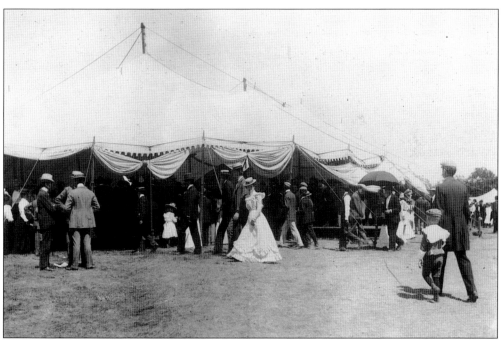

BIG CHAUTAUQUA TENT. Theodore Roosevelt called it "the most American thing in America," and the arrival of the big tents evoked excitement at the thought of the ensuing entertainment and culture. This very large tent that is drawing a crowd might have held a popular speaker, such as William Jennings Bryan, or perhaps a musical troupe. Religious instruction was another favorite of many, but Chautauquas were nondenominational.

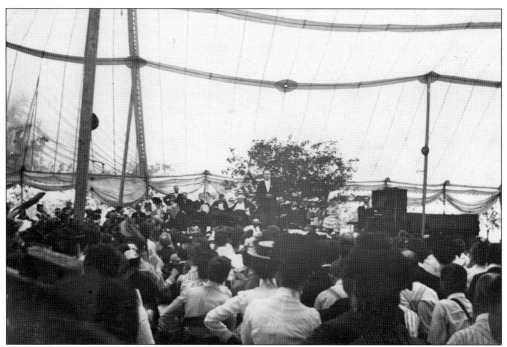

INSIDE THE BIG TENT. It is not known who this speaker is, but he has the rapt attention of the audience as well as dignitaries on the stage, one of whom is Clark E. Carr. There is also a piano player on the stage, so this may have been a religious speech or a talk about temperance, with sing-alongs afterward to rally the audience.

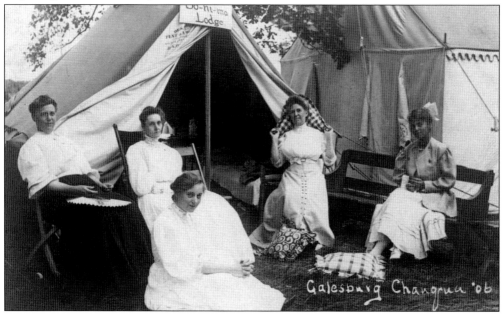

CHAUTAUQUA CAMPERS. These ladies are taking a break in 1906 by their tent, which they christened the Bo-ni-ma Lodge. Lectures were the most widely attended events, but music and religious programs were also popular. Chautauquas lost their appeal in the late 1920s, with the availability of radios and motion pictures.

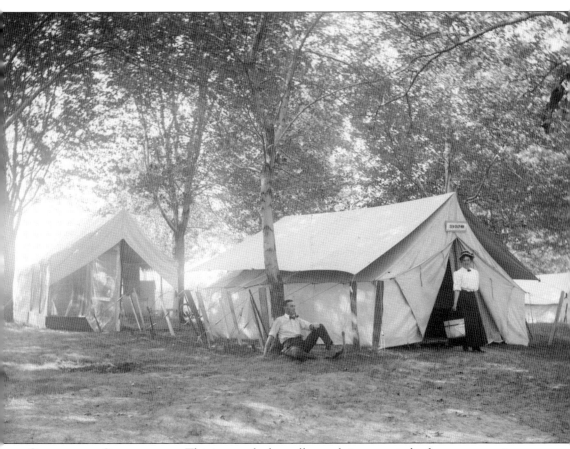

CHAUTAUQUA CAMPGROUNDS. This image of a day well spent brings to mind soft summer evenings and time to discuss what had been heard that day. A man sits against a tree smoking a pipe. The lady of the family is carrying what appears to be a bucket of water, but she seems relaxed and happy. They have named their tent the Dew-Drop-Inn.

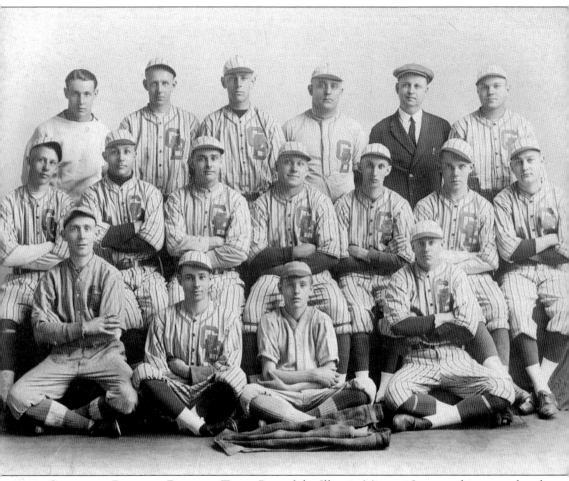

GALESBURG BOOSTERS BASEBALL TEAM. Part of the Illinois–Missouri League, this team played for Galesburg from 1908 to 1910. Grover Cleveland Alexander pitched for the Galesburg team for the 1909 season and threw a no-hitter. He was sold to another team during the 1910 season after an injury left him with double vision.

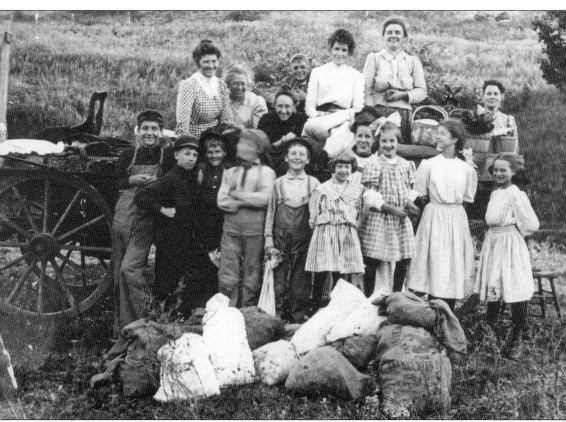

NUTTING PARTY AT LAKE GEORGE. These children and ladies are enjoying a warm autumn day at Lake George, near East Galesburg, to gather several bags of nuts. What they probably found were black walnuts and hickory nuts. Hickory nuts were especially enjoyed in cakes, and walnuts were a favorite in fudge, as they are today.

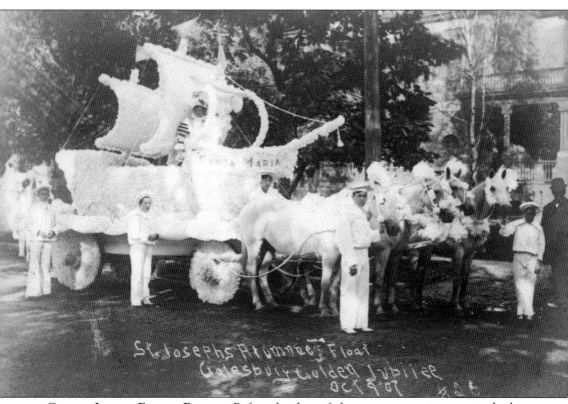

GOLDEN JUBILEE FLOWER PARADE. Before the days of electronic entertainment in the home, parades were a favorite event, and Galesburg had many. A competition of sorts was held, with a floral parade during Galesburg's golden jubilee on October 9, 1907. Citizens were encouraged to wear their Sunday best and decorate wagons, buggies, and anything that could be pulled by a horse. This flower boat is from St. Joseph's School.

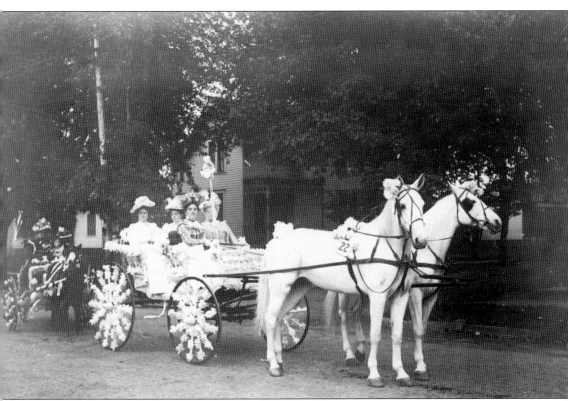

GOLDEN JUBILEE PARADE. Another contender for the most beautifully decorated horse-drawn conveyance is shown here. Even the horses have been adorned with flowers. The vehicle on the left is being pulled by a pony. It is not known how many rigs were entered into the contest, but this one is no. 22.

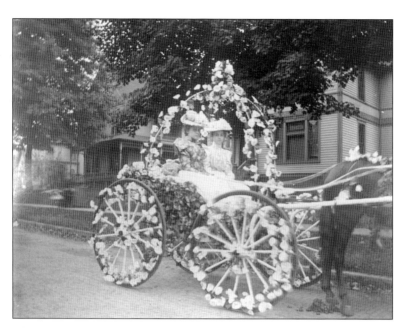

FLORAL BUGGY. Two young ladies have decorated their buggy as a floral pergola for the golden jubilee parade. With their large hats and frilly dresses, they look like they are right out of the movie *Meet Me in St. Louis*. Many of the horses were decorated as well and brushed until their coats shined.

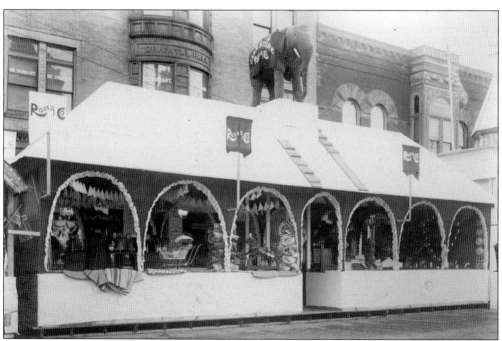

ROSS & COMPANY. During the weeklong festivities of the golden jubilee, store owners and entrepreneurs set up booths to sell their wares. Here, the Ross & Company Store has a papier-mâché elephant on top. The store seemed to sell everything, from bananas to dress goods to rocking horses.

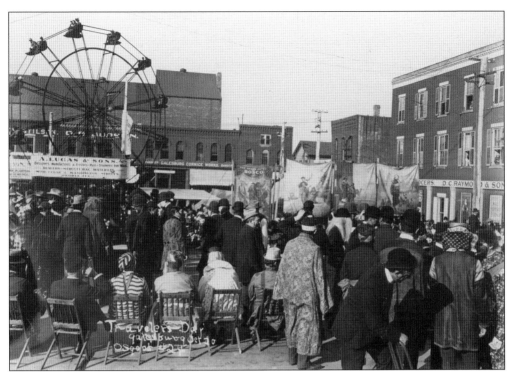

TRAVELING MEN'S DAY. In 1910, traveling salesmen were dressed in various costumes celebrating Traveler's Day on the Public Square. This unofficial holiday gave these knights of the road a chance to meet, swap stories, and march in a parade on East Main Street. The most visible feature in this photograph is the Ferris wheel, invented by Galesburg native George Washington Gale Ferris before 1893.

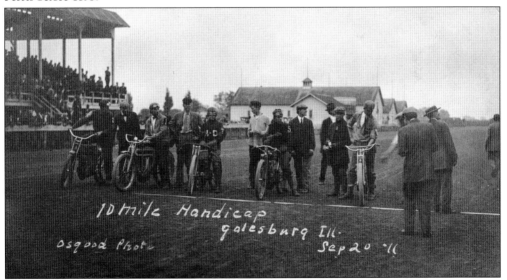

10-MILE HANDICAP MOTORCYCLE RACE. Here, five daredevils are about to begin racing on the dead-level track at the old District Fairgrounds on September 20, 1911. The grandstand appears to be packed. The entrance to the old fairgrounds can still be seen at 2262 Grand Avenue, where large concrete pillars with balls on top still stand.

WEINBERG ARCADE ROOF GARDEN. Big bands used to play on weekend nights at the Roof Garden, including the Dorsey Brothers, Lawrence Welk, and Wayne King. It did not cost a lot to get in, but if people did not have money, they could dance with their dates on the sidewalk below. It must have really been something to have that wonderful music wafting through downtown. The Weinberg Arcade was a respectable place, with a great dance floor, and no liquor was allowed.

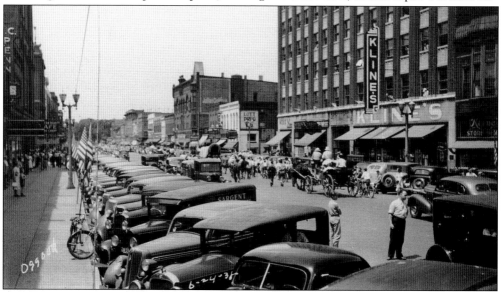

DOWNTOWN GALESBURG. Downtown is packed with cars, parked diagonally. Taken on Friday, June 24, 1938, Memorial Day, the photograph shows the sidewalks and street buzzing with business, and American flags are in abundance. Stores that can be seen are (left) J.C. Penney and the (right) Bondi Building and Kline's.

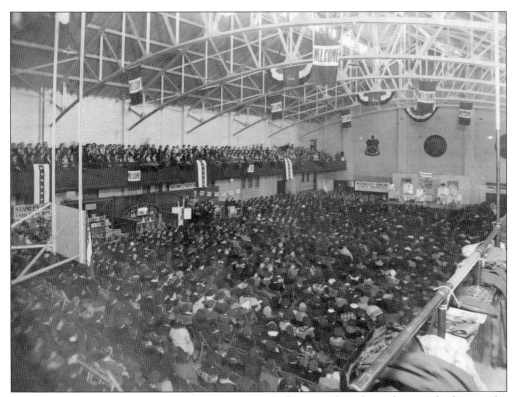

AUDIENCE AT THE ARMORY. On February 23, 1935, the annual cooking show took place at the Galesburg Field Artillery Armory. On the stage, two women dressed in white showed how to prepare delicious meals to a packed house. On the stage with them were two stoves, two refrigerators, and a Hoosier cabinet. Local and national sponsors helped cover the cost of the show, including Maytag, Lux Soap, and Brown, Lynch, Scott.

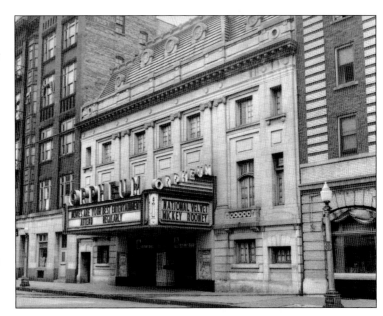

ORPHEUM THEATRE. This theater, originally part of the Orpheum circuit of vaudeville theaters, opened in 1916. Performers such as Al Jolson and the Marx Brothers played at the Galesburg Orpheum. Sometime in the 1920s, it began showing movies with live entertainment, and a large pipe organ was installed. It closed in 1982, and the organ is gone. But after massive renovation, it reopened in 1988.

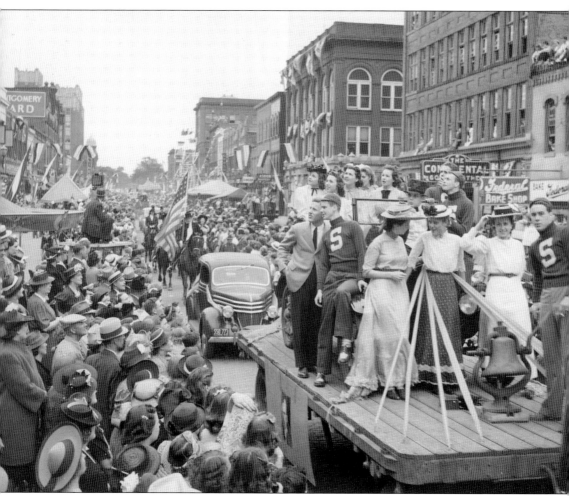

Movie Parade. In May 1939, a parade in Galesburg celebrated the premiere of the movie *Those Were the Days*, loosely based on George Fitch's books about his student life at Knox College. The film starred William Holden. Knox College students played extras, and some are shown on this float. (Courtesy of Dr. John Bohan and family and ACE Photographs.)

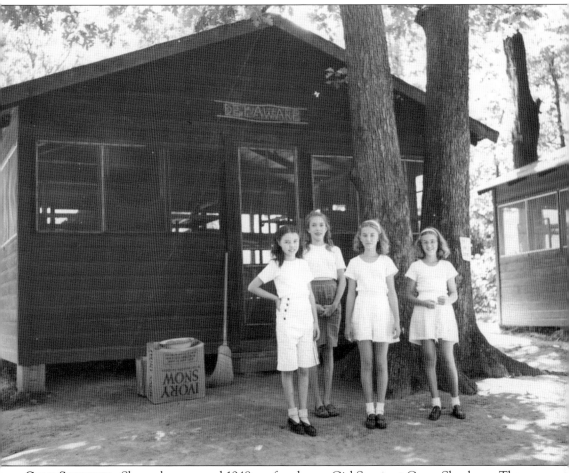

CAMP SHAUBENA. Shown here around 1948 are four happy Girl Scouts at Camp Shaubena. The girls are standing in front of their cabin, given the name Delaware. The two girls on the left are believed to be sisters Joy and Sue Brown. The girls may have been on their way to archery practice, swimming, or a craft lesson. (Courtesy of the Ray M. Brown family.)

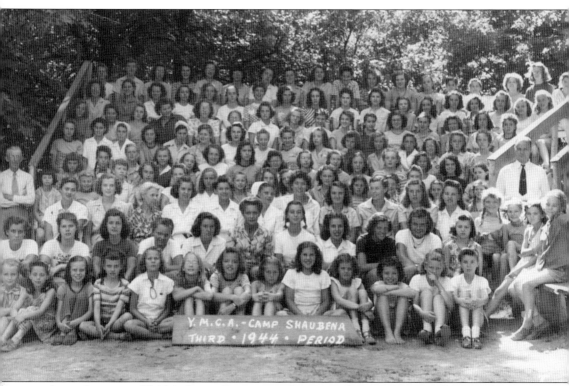

Camp Shaubena YMCA Group Portrait. This image shows approximately 140 girl campers, camping guides, and administrators at Camp Shaubena. It was the third session in the summer of 1944. Each year, six sessions were held, divided equally between boys and girls. The camp was not free; parents had to pay for their children to attend, but some saved up their own money to be able to attend.

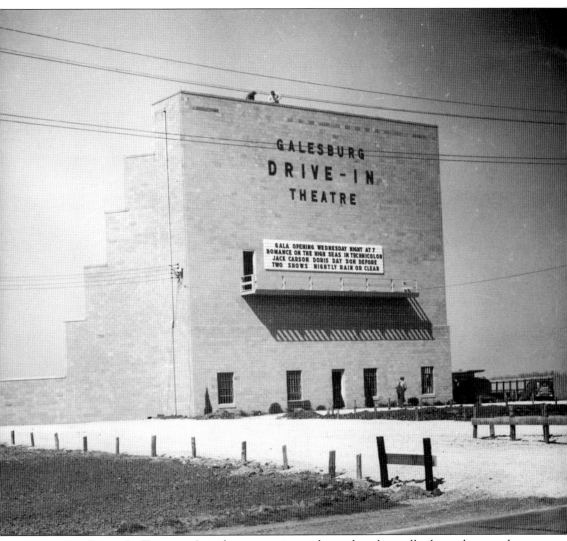

GALESBURG DRIVE-IN THEATRE. It is almost opening night, and work is still taking place on the brand-new, 12-acre drive-in theater, located one mile west of city limits. The film for the gala opening on April 27, 1949, was *Romance on the High Seas* with Doris Day. Some of the advertised advantages to a drive-in were that folks could dress as they liked, smoke if they wanted to, and did not have to worry about parking.

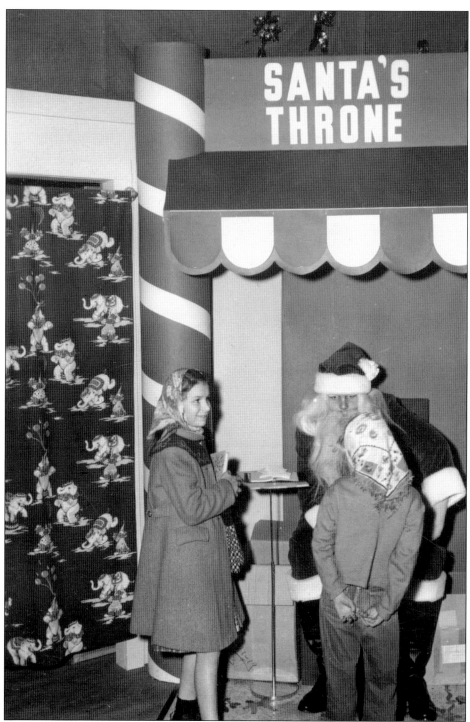

SEEING SANTA. Who does not remember going to see Santa and being thrilled, but also shy. This particular Santa was at Sears in Galesburg at 467–469 East Main Street. From the looks of the girls' clothing, it appears to be sometime in the 1950s. The girls may be grandmothers by now, seeing or hearing about their own grandchildren going to see Santa.

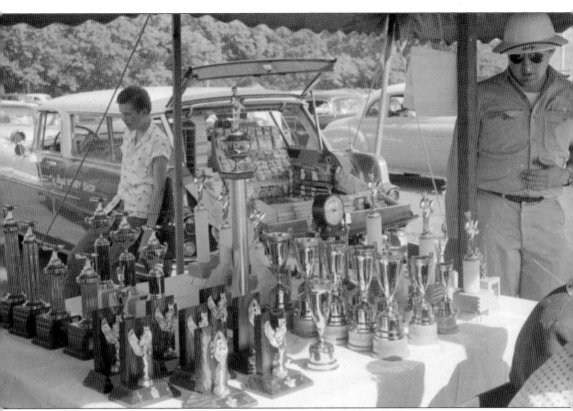

MODEL AIRPLANE CLUB. The Galesburg Model Airplane Club took off in popularity in 1958. The Exchange Club and local merchants sponsored boys to deter juvenile delinquency. The men helped boys build and fly their own model airplanes, and a competition was held at Lake Storey, just north of Galesburg. Trophies were provided by Ray Johanson's Hobby Shop.

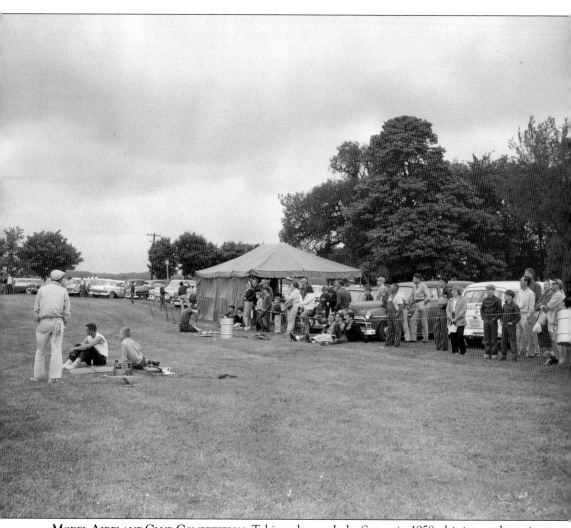

MODEL AIRPLANE CLUB COMPETITION. Taking place at Lake Storey in 1958, this image shows just a few of the nearly 1,000 spectators who came to see model airplanes flown by sons and husbands or, just out of curiosity, compete in different maneuvers and races at this daylong event.

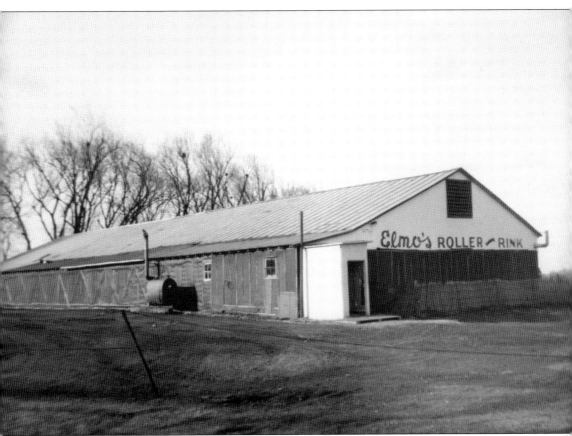

ELMO'S ROLLER RINK. Opened in 1936 by Elmo and Callie Caldwell, Elmo's was a popular destination for skating. Located north of Lake Storey Park, it was open daily and evenings, and it had a real organ for live music, not records. In the summer months, the wooden sides opened to let in the breeze, and parents could watch their kids skating from their cars. Elmo's closed in 1962.

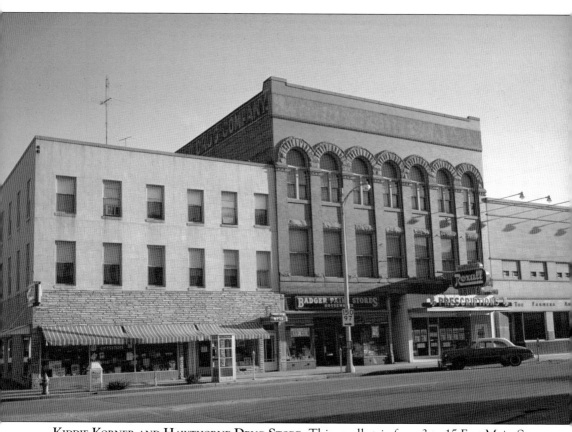

KIDDIE KORNER AND HAWTHORNE DRUG STORE. This small strip from 3 to 15 East Main Street brings back memories of a great toy store with model-car racing in the back. Hawthorne Drug store was also called Rexall Drugs by locals. At one time, the pharmacy had a soda-fountain counter and served a drink called a Creamo. They are now all gone, in the name of progress. (Courtesy of William Gliessman.)

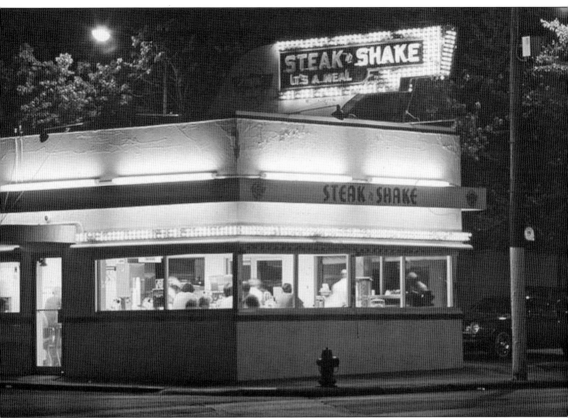

STEAK 'N' SHAKE. Located at 981 East Main Street, this fondly remembered small drive-in restaurant opened sometime in the late 1930s and moved to Henderson Street around 1974. A perennial favorite for its savory hamburgers and fries, it was also the turnaround point for teens in cars cruising the strip on Friday and Saturday nights. This photograph was taken around 1970. (Courtesy of John Lotspeich.)

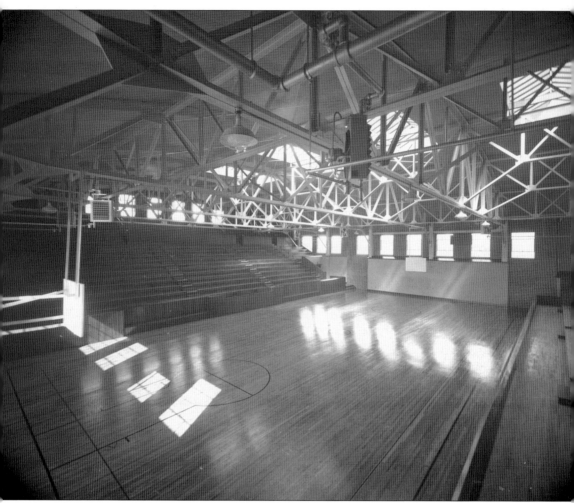

STEELE GYMNASIUM. Whether playing basketball or sitting in the bleachers, residents of a certain generation cannot forget Coach Thiel, the squeak of tennis shoes on the polished floor, the school band, and the Streak fans yelling "swoosh!" when the ball made it into the hoop. Whether one attended the Steele Gym, or the gym at the new high school on Fremont Street, those were the days!

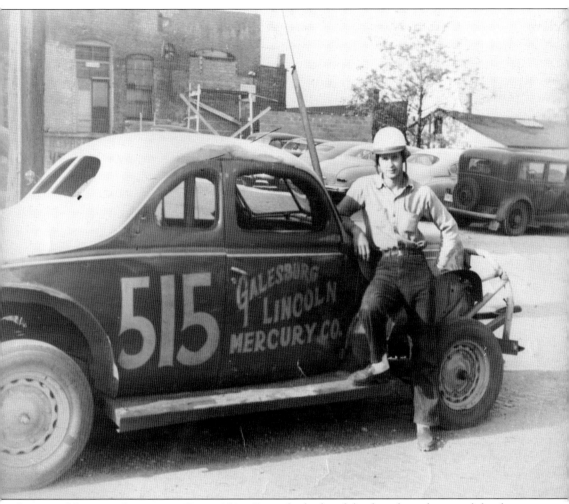

LINCOLN MERCURY SPONSORED CAR, 1950s. From the looks of this bare-boned automobile, the unidentified driver is either going to a stock-car race or to the demolition derby, both held every year at the Knox County Fair. And, who can forget racing cars out on a country road?

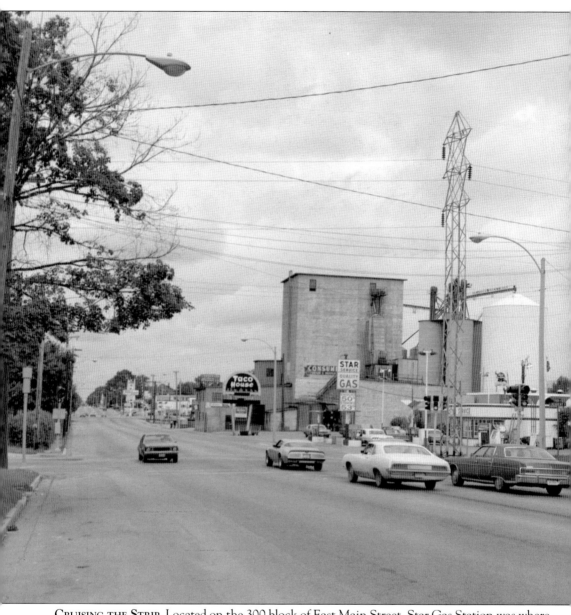

CRUISING THE STRIP. Located on the 300 block of East Main Street, Star Gas Station was where many teens pooled their change to get a few gallons of cheap gas to go cruising on the main drags of Henderson and Main Streets on the weekends to see, and be seen, while trying to look cool.

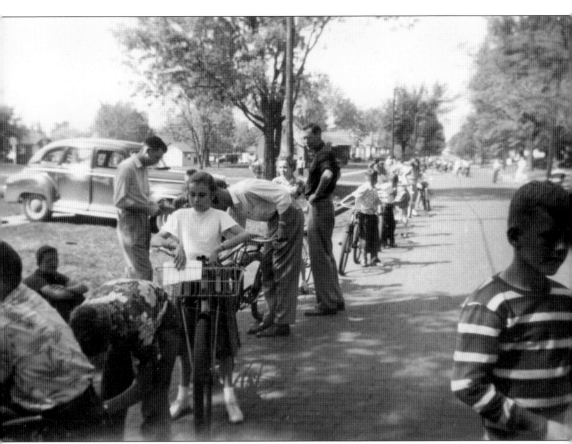

BICYCLE SAFETY DAY. For the younger drivers, there was bicycle safety day. Kids would line up with their bikes, ride around obstacles using the proper hand signals, and get a certificate. In addition, reflective tape was put on their fenders. The children would then race home, happy to be a kid in America.

MIDWAY AT THE COUNTY FAIR. The Knox County Fair offered rural teens a place to go and have fun. Whether they went for the rides, the food, to play games of chance, or just to look around and see who else was there, it was always a fun way to spend a day or evening.

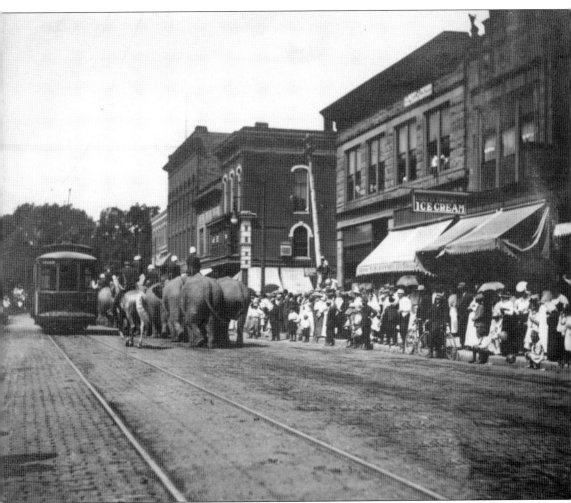

THE BIG END. Circus elephants lumber toward the Public Square after a parade. With their tails wagging, one can almost imagine them saying a fond farewell to the Galesburg of the good old days.

Discover Thousands of Local History Books
Featuring Millions of Vintage Images

Arcadia Publishing, the leading local history publisher in the United States, is committed to making history accessible and meaningful through publishing books that celebrate and preserve the heritage of America's people and places.

Find more books like this at
www.arcadiapublishing.com

Search for your hometown history, your old stomping grounds, and even your favorite sports team.

Consistent with our mission to preserve history on a local level, this book was printed in South Carolina on American-made paper and manufactured entirely in the United States. Products carrying the accredited Forest Stewardship Council (FSC) label are printed on 100 percent FSC-certified paper.